BRITAIN IN OLD P

CW00584873

ISLE OF MAN

IAN COLLARD

The History Press

First published 2013

The History Press
The Mill, Brimscombe Port
Stroud, Gloucestershire, GL5 2QG
www.thehistorypress.co.uk

British Library Cataloguing in Publication Data.
A catalogue record for this book is available from the British Library.

ISBN 978 0 7524 9100 4

Typesetting and origination by The History Press
Printed in Great Britain

CONTENTS

	Introduction	4
1	Douglas	7
2	Ramsey	39
3	Peel	53
4	Port Erin	57
5	Port St Mary	61
6	Castletown	65
7	Laxey	69
8	Trains, Boats and Planes	73
9	Manx Traditions, Customs and Scenery	109

INTRODUCTION

Then rises like a vision
sparkling bright in Nature's glee,
My own dear Ellan Vannin
with its green hills by the Sea.

Stanza from Ellan Vannin.

The Isle of Man is situated in the Irish Sea with a coastline of 80 miles and a range of hills stretching across the island from Ramsey in the south west. The north of the Island is generally low-level farming land and the highest point is Snaefell, which is 2,034ft above sea level. It is known as Ellan Vannin Veg Veen, 'The Dear Little Isle of Man', and has also been referred to as Mona, Manaw and the Scandinavian's used the name Mon or Maon. The names appear to be derived from the fact that it is a 'mountainous or hilly land'.

The River Dhoo runs down from Greeba Mountain until it meets the Glass about a mile from Douglas. It then flows down southwards, becoming the Dhoo Glass. Douglas developed as a fishing village in the Irish Sea herring fishery and residential, commercial and military facilities were built. The town also became a base for smuggling activities in the early eighteenth century, and the population increased from around 800 in 1710 to nearly 2,500 in 1784. Around 1830, it was decided to start a regular steam packet service to Liverpool for the people of the Island and also to enable visitors to spend holidays in the Isle of Man with their families. The number of visitors reached its peak for the jubilee in 1887.

The first town council was elected in 1860, and between 1876 and 1878, the new Loch Promenade was constructed at a cost of £30,000 and large properties were built with sea views. In 1869, Douglas became the Island's capital and visitors normally arrived at the Red Pier, near the site of the steam packet's main office. By 1891, 35 per cent of the Manx population were living in Douglas, where the Town Hall, which inclues a Council Chamber, was opened in 1899 in Renaissance style. The Legislative Buildings, built in 1894, incorporate the Keys Chamber and the Tynwald Court. At the entrance are the armorial bearings of the Norse Kings of Man and the Rolls Office contains all the public records of the Island which were previously kept at Castle Rushen. The Kings of Mann was the title taken by the various rulers over the Kingdom of Mann.

The name Ramsey is derived from the Norse Hramm's-ey, or Raven's Isle and Hrams-a, meaning 'wild garlic river' from Old Norse. The town has been the site of many battles. In the *Chronicles of Mann*, published around 1250, the town was recorded as 'Ramsa', which was drawn from the old Scandinavian language. The present spelling of the name first appeared in the manorial roll of 1703 and is also thought to derive from the Manx, 'Rhumsaa'. Ramsey is divided into two

parts by the river and the harbour. Northwards it is mostly modern and the town is situated to the south between the quay and the promenade. It is the only town on the Island to have an iron pier, which was built in 1886 and named after Queen Victoria.

Peel was once the seat of the bishop and is referred to as the City of Peel or the 'rose red city'. St Patrick's Isle is located at the mouth of the harbour and this is now connected to the mainland by a roadway. The name is derived from the Celtic 'pil', meaning fortress. The first Irish missionaries arrived at St Patrick's Isle in the late fifth century and a round tower was built by the monks as a place of refuge. Work on the cathedral was started in the thirteenth century by Olaf II, who was one of the last Viking Kings of Man, and it took over two hundred years to complete. St Patrick's Isle is named after Ireland's patron saint as he is reputed to have brought Christianity to the Island and established German as the first bishop. German was a canon who remained on the Island for a year and then moved to Wales to help the Britons who were in conflict with the Saxons. He was later canonised. The Gaelic for the city is Purt ny Hinshey, which translates as 'island town'.

Port Erin is situated on the south-west coast of the Island. The bay is square in shape and runs inland for approximately a mile between the headlands. Port Erin is translated from Manx Gaelic as Purt Chiarn, which means either Lord's Port or Iron Port. It was a small fishing village, which developed into a popular family holiday resort. The breakwater was designed on the lines of that of Plymouth by Sir John Coode and was intended to be 950ft in length. However, during construction it was severely damaged by a violent storm in January1884.

The name Port St Mary comes from the Gaelic 'Keeill Moirrey' or 'Purt le Moirrey', the Chapel of St Mary of Rushen Abbey that once stood on the cliff overlooking Chapel Bay. It was once the southern headquarters of the Manx fisheries and boasts a factory that processes 'queenies', the local shellfish delicacy. The Chasms are a series of fissures of varying width and depth that lead to Black Head and Spanish Head, which is named after a ship of the Spanish Armada that came ashore at the foot of the cliff.

In July 1953, well-known travel writer S.P.B. Mais took a holiday in the Isle of Man, and he described Laxey as one of the most pleasantly situated of the Manx seaside resorts. Mais stated that, 'Laxey lies partly in a long winding valley which is well protected by the surrounding hills and the sea cliffs overlooking a spacious beach, which in turn is protected by two fine headlands.' It is famous for the great wheel, which is reputed to be one of the largest in existence. The Manx Electric Railway runs to the summit of Snaefell through the path of the River Laxey, to Bungalow station on the TT course and then makes a complete circle around the sides of the mountain. Laxey is an ideal centre for hill walkers with the summits Pen-y-Pot, North Barrule, Slieau Lhean, Slieau Ouyr and Slieau Ruy all accessible and within three or four miles of the town.

Ian Collard, 2013

1

DOUGLAS

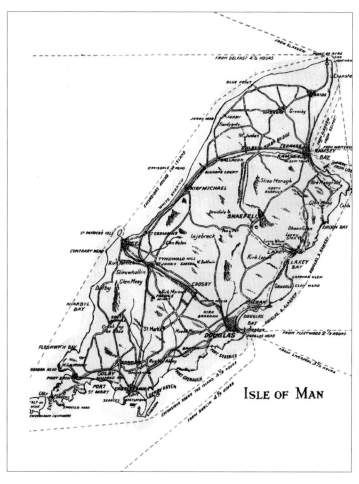

Map of the Isle of Man.

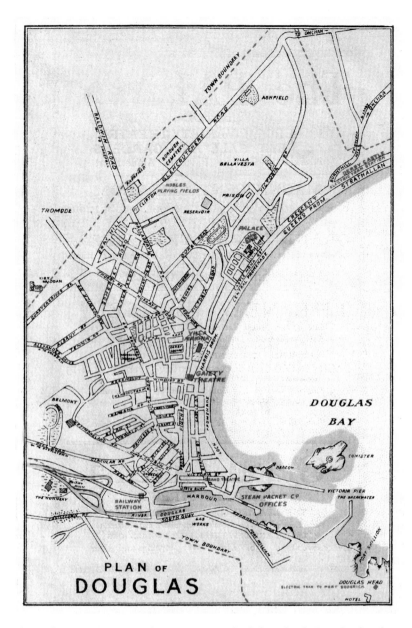

PLAN OF
DOUGLAS

Map of Douglas in 1923. Since becoming capital of the Island, Douglas has been the main destination for holidaymakers and visitors. As people came off the Steam Packet vessels, they saw the Victoria Buildings – a triangular block with a clock tower. The new sea terminal has now been built which provides booking, luggage handling and tourist information facilities, as well as a café and shop. A frequent bus service and the Douglas trams provide good public transport services along the length of the promenade and to other destinations on the Island. The main shopping centre in Douglas can be found in the narrow Strand Street that runs behind the Loch Promenade. As well as the entertainment venues, Douglas is the starting point for the Steam and Manx Electric Railway. It is also the seat of government and the centre of business and social life on the Island.

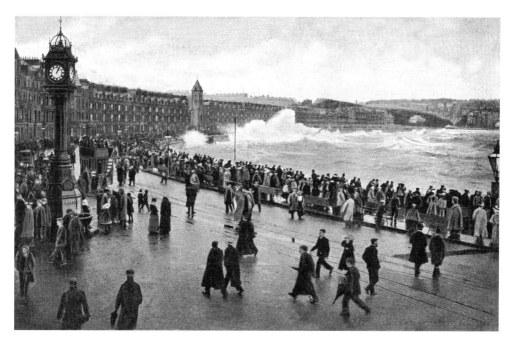

A storm in Douglas Bay. The town and promenade are exposed to the strong winds and gales that are prevalent in the Irish Sea during the winter months. Most of the storms only last a few days, but they can cause flooding and closure of the promenade.

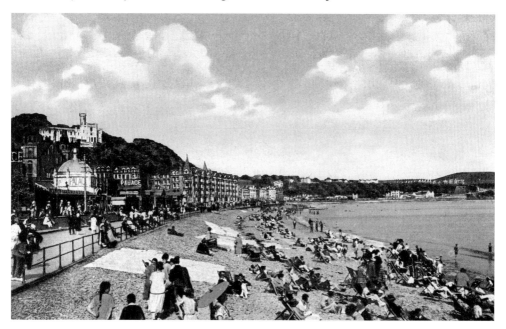

The beach at Douglas was one of the main reasons for visiting the Isle of Man, and many people came to enjoy a holiday by the seaside and walk the stretch of beach. Together with the extensive facilities provided by the shops, cafés, and restaurants, this made it an ideal place to relax and enjoy the sunshine.

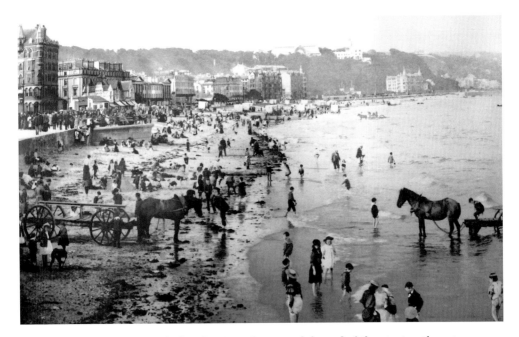

Crowds of holidaymakers on the beach at Douglas around the end of the nineteenth century. In 1870, there were 60,000 visitors annually and by 1884, this had increased to 182,000. Over 300,000 people visited the Island three years later for Queen Victoria's Golden Jubilee.

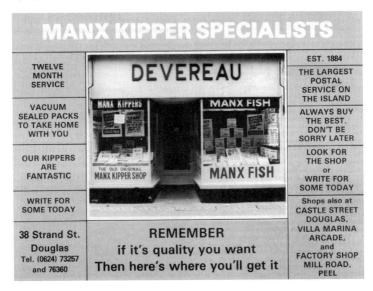

An advertisement for Devereau kippers and Manx fish. Devereau's is a family run business that operates from Castle Street in Douglas and a factory shop in Peel. The business was established in 1884 by the Devereau family. Peter Canipa obtained a job with the firm delivering fish and kippers to the hotels along Douglas Promenade. He bought the company from the Devereaus in 1972 and the firm now has two kipper shops and the large kipper-curing factory. On top of this, they supply to markets and shops across the whole island and to fish markets in Fleetwood, Manchester, Liverpool, London and Grimsby.

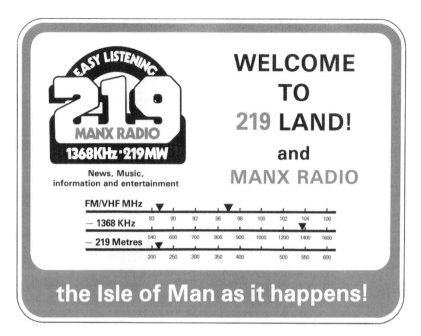

Manx Radio started broadcasting in June 1964 and the station operated from a caravan parked in a field outside Douglas. It consisted of a small studio, a VHF transmitter, a kitchen and a toilet. In October 1964, the station commenced operations on the medium waveband on 188 metres and it broadcast its first commercial. In May the following year, the station moved to the basement of a billiard saloon on the Douglas seafront. It also started to operate on the 232 metres waveband, which it broadcast on for thirteen years. In October 1969, the station moved to its present home on Douglas Head, with five studios having views across Douglas Bay. It was built during the Second World War for the Royal Navy to train radar operators. Manx Radio medium wave transmissions moved to 219 metres in November 1978 and news and current affairs is an important part of the station's output. It broadcasts on 1368 kHz AM – 89.0 MHz for the north of the Island, 97.2 MHz for the south and 103.7 MHz for the Island's hills. A low-power transmitter covers Ramsey on a frequency of 89.5 MHz.

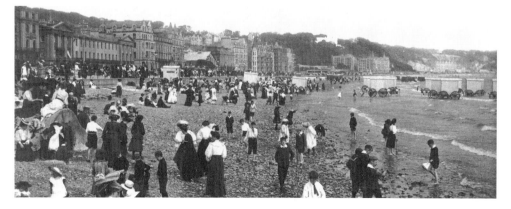

Holidaymakers on the beach at Douglas in 1911, around numerous bathing huts on wheels situated in various positions on the sand. These were used for changing into and out of bathing costumes and for storing personal belongings.

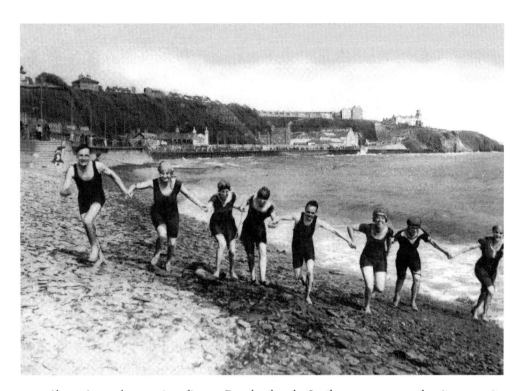

Above: An early morning dip on Douglas beach. In the summer months, it was quite common to see groups and individuals enjoying a swim in the sea prior to breakfast.

Left: Port Jack and Douglas Bay Hotel. Port Jack is the first stopping place on the Manx Electric Railway. It was opened in 1893 and was a busy place for tourists on their way to the White City, which was situated along the coast. The Douglas Bay Hotel was built from red brick stone with a tower in the centre of the building, and was sadly gutted in a serious fire in 1988. Before that, the hotel offered its guests a sun lounge, hot and cold running water, a ballroom, lawns and a passenger lift! The Texas Bar, which was a Wild West saloon, was very popular and a swimming pool was built for the use of the residents. The site has now been developed into offices for the Royal Skandia Group and a circular tower has been incorporated into the new design.

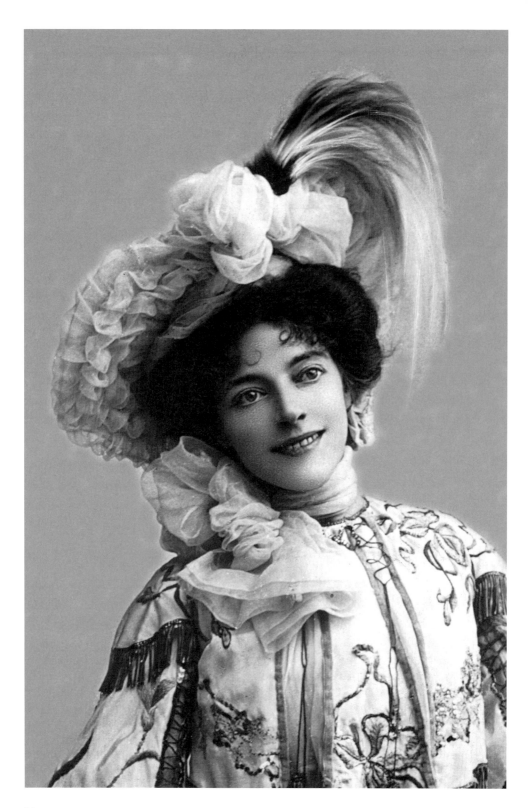

Above: A group at the Café Chantant on the Isle of Man on 14 August 1905. A 'café chantant' was a musical café that offered an intimate cabaret with sophisticated musical entertainment. They were normally situated outdoors where small groups performed popular music for the public. The music was light-hearted and not particularly political or confrontational. It was popular in Paris and London in the eighteenth century, and again in the late nineteenth and early twentieth centuries. They were known as 'café cantante' in Spain, 'kafesantan' in Turkey and 'kafe-shantan' in Russia. The name appears in 'Araby' – a short story written around 1904–05 that was published in 1914 in James Joyce's *Dubliners*. They were obviously very popular at the time this photograph was taken as they were also mentioned in *The Man Who Was Thursday: A Nightmare*, by G.K Chesterton, published in 1908. The back of the postcard also refers to Mrs Shaw, Rockcliffe House, No. 6, Church Street, Douglas and Mrs Kelly, Sunnyside House, Christian Road, Douglas as being, 'both splendid places for gentlemen'.

Left: Ada Reeve in 1905. She was one of many stars that played in the theatres in Douglas during the summer season. Reeve was born in London in 1874 and was an English actress of both stage and screen. She began performing in pantomime and music hall shows as a child and later specialised in Edwardian musical comedies. She toured Australia, South Africa and America in variety and vaudeville, and from the age of seventy, she began starring in films. Reeve appeared in the Isle of Man in 1905 when she was co-producing and headlining in the play *Winnie Brooke, Widow*. She also played the title role in *The Adventures of Moll* on tour, and appeared as Aladdin in the Christmas pantomime at Birmingham. The following year she toured South Africa with her husband and on return appeared at the Tivoli and Empire theatres on tour. She was known for her roles in variety and was on tour around the world from 1929–35. Following the end of the Second World War, she began appearing in films, continuing her stage work in the 1940s and 1950s. Ada retired from the stage at the age of eighty but made two more films, appearing in *A Passionate Stranger* in 1957. She died in 1966 at the age of ninety-two.

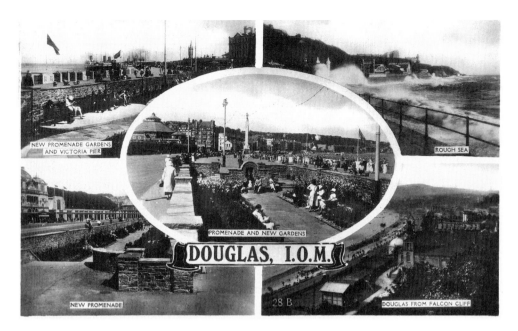

Multi-view postcard featuring scenes of Douglas in the 1960s.

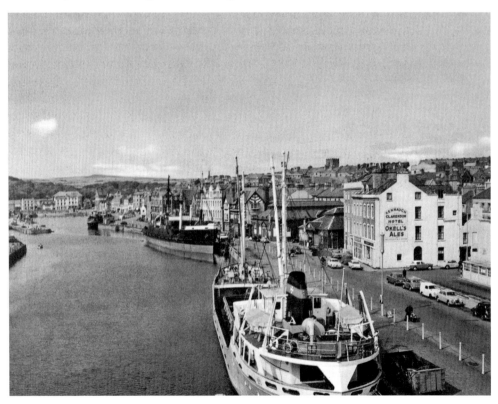

Coastal cargo vessels in the Inner Harbour at Douglas. The Inner Harbour was once a busy port with coastal cargo vessels loading and discharging their goods onto the quayside.

A Holiday to Remember

ISLE OF MAN INTERNATIONAL CYCLING WEEK

June 19th–25th, 1960

Your "All-in" Holiday Plan

Seven days from £9 0s. 0d.

●

"All-in" Holiday Ticket will include:

2nd Class return Boat Fare and Cycle Ticket

Full Board Residence for the week in hotels of your own choice from Official List

Grand Stand Enclosure Tickets for Massed Start Racing—Amateur and Professional

Cinema Ticket

Track Meeting Admission Tickets

Presentation Ball and Buffet Reception

Rally Meetings and Excursions

Souvenir Programme for all events

●

Brochure and Full Details from:

THE CYCLING FESTIVAL DIRECTOR

ISLE OF MAN TOURIST BOARD

13 VICTORIA STREET, DOUGLAS, I.O.M.

International Cycling Week, 1960.

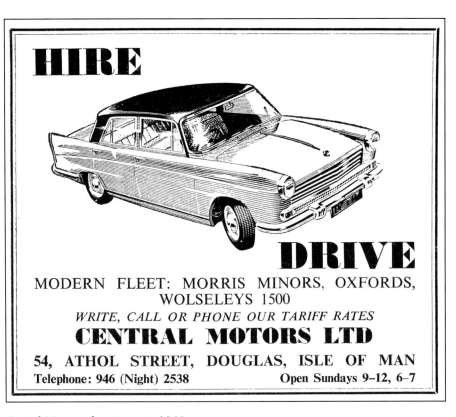

Central Motors advertisement, 1960.

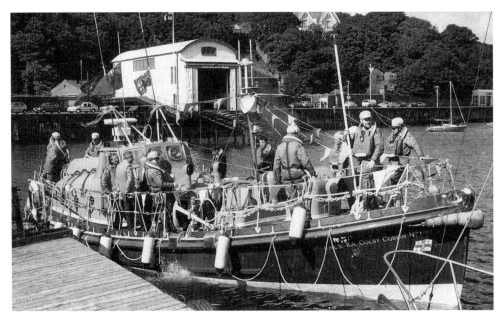

The RNIB, 'R A Colby Cubbin No 1' sets off for Douglas Promenade to participate in her last lifeboat day on 29 July 1988. (*Courtesy of Mannin Postcards*)

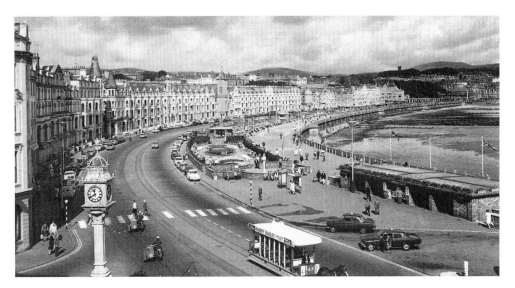

Loch Promenade and Victoria Street is the first sight of Douglas that visitors get as they leave the Sea Terminal and negotiate the busy main road on their way to their holiday accommodation. The buildings are mainly hotels and the sunken gardens opposite are a sun trap on a summer day.

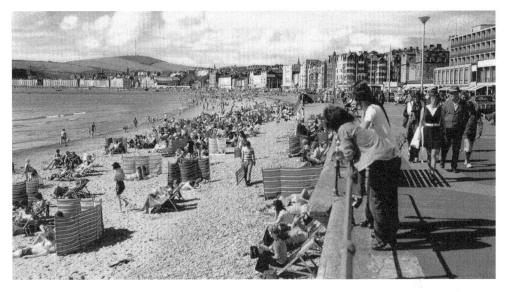

The promenade at Douglas. The beach, ideal for sunbathing and sheltered from most of the prevailing winds, was one of the main reasons for coming on holiday to the Isle of Man. Many people came to Douglas to enjoy a holiday by the seaside and the stretch of beach, together with the extensive facilities provided by catering and leisure operators, was perfect for relaxing and enjoying the sunshine. In 1870, there were 60,000 visitors annually and by 1884 this had increased to 182,000. Over 300,000 people visited the Island three years later for Queen Victoria's Golden Jubilee. The promenade has changed little over the years apart from the lack of large crowds of holidaymakers since the 1980s.

It has been claimed that the Cunningham Young Men's Holiday Camp at Douglas was the very first holiday camp. Accommodation could be found in the form of tents and when Billy Butlin opened his first holiday camp in 1936, there were approximately 60,000 campers per year at Cunningham's in Douglas.

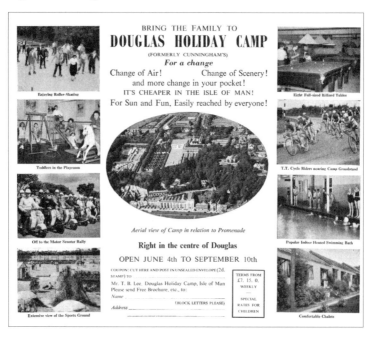

The Camp was founded by flour dealer and baker Joseph Cunningham and his wife Elizabeth, who were from Liverpool. As superintendent of the Florence Institute in Toxteth, Cunningham attempted to organise summer camps for young people from Liverpool.

The Cunninghams moved to the Isle of Man in 1890 and two years later chose Laxey as the site for a camp, but, by 1894, they decided to develop one at Howstrake, near Groudle. The Howstrake Camp opened that year and attracted around 600 young men every week. It was open from May to October and by 1900, it cost 17/6d a week. Five acres of land were acquired in 1904 at Victoria Road where 1,500 tents and a dining pavilion were erected. The camp advertised that each tent could sleep up to eight men and many holidaymakers came back to the camp each year.

During the First World War, the site was used as an Internment Camp and Ellerslie Farm was purchased in 1915, which enabled it to be self-supporting with its own dairy. Under supervision, the internees built permanent accommodation and these chalets were available for holidaymakers from the end of the war. In line with the Cunninghams' staunch Presbyterian beliefs, a no alcohol policy was adopted at the camp. Joseph Cunningham went on to become a scout leader on the island, as well as a member of the House of Keys and was later elected to the Legislative Council of the Isle of Man. He died in 1924. The camp was taken over again during the Second World War as HMS St George, which was a training school for the Royal Navy. Ballakermeen High School was also used in conjunction with the camp to provide classrooms. The camp was handed back to the family in 1945 but it was gradually developed into residential and holiday accommodation.

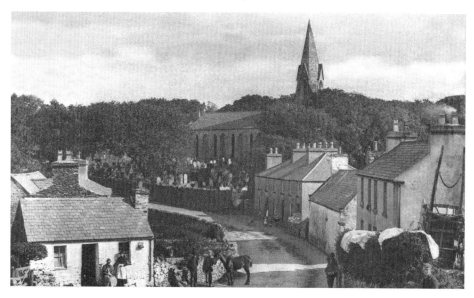

Imperial Terrace, Royal Avenue West and the church and village of Onchan, in 1912. The church at Onchan is famous because the spire has neither a cross nor a vane. St Peter's Church is small and was rebuilt in 1833; originally it was the Church of St Conachan. The Governor's Chapel adjoins the chancel and there is a runic cross in the porch that is similar to those found at Kirk Braddan.

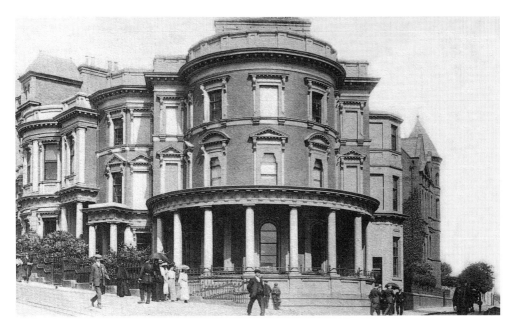

The House of Keys at Douglas. As the Isle of Man is an independent country, bills are introduced in the House of Keys by Chairmen of the Boards of Tynwald. The Manx Parliament meets in the Legislative Buildings where there are three chambers, one for the House of Keys, one for the Legislative Council and a third for the Tynwald, where the two Houses combine under the chairmanship of the Governor. The Legislative Building was opened in 1894.

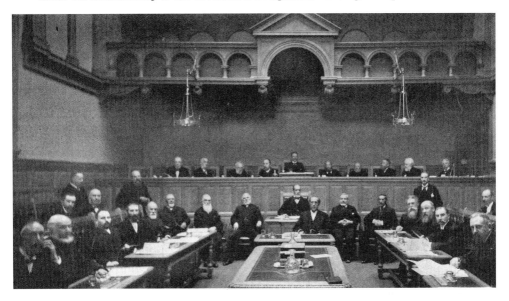

The Keys Chamber is on the ground floor, and the Tynwald Court is above. Stained-glass windows show the arms and portraits of significant people in the history of the Island, and over the public entrance are the armorial bearings of the Norse Kings of Man. The public records of the Island are kept in the Rolls Office. The building also contained the offices of the public analyst and other government officials.

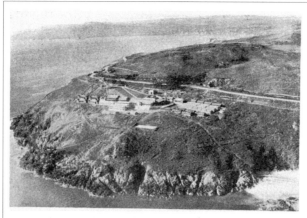

Advertisements for the Howstrake Holiday Camp and Douglas Holiday Camp. The Howstrake Holiday Camp at Onchan was operated by the same company that ran the Cunningham Camp, situated four miles away. The Douglas Holiday Camp was established in 1907 by T.B. Carrick, who was from Liverpool, and his niece. The Howstrake Holiday Camp Limited was established three years later and Mr Carrick's niece married Mr R.A. Taylor. By 1922, the camp was advertising places for 450 gentlemen and accommodation was in tents and bungalows, 'together with spacious dining, lounge and billiard rooms and good storage for motor cycles.' Several years later, there were around sixty tents and about a dozen buildings forming the dining room, chalet accommodation, and entertainment facilities. There were also tennis courts and an open-air swimming pool. During the 1930s a dance floor was added, a resident orchestra provided entertainment, games and excursions were organised, a physical training instructor was employed and four meals a day and hot baths were also part of the package. A notice to auction the camp in February 1936 stated that it had accommodation for 500 guests, quarters for forty-four staff and that it occupied 20 acres. It was later withdrawn from the auction process and by 1937, accommodation was provided for women and a new dining room was opened the following year, catering for 750 guests.

In September 1939, the camp was used as temporary accommodation for the 129th Battery of the Manx Regiment. In January 1940, it was the shore establishment for boy sailors of the Royal Navy. 'Boy sailors' were aged between sixteen to eighteen years of age and on their eighteenth birthday would automatically become rated as ordinary seaman. In July 1941, the camp became the Royal Naval School of Music. The camp was popular and profitable following the end of the war and, in 1969, a modernisation programme worth £50,000 was completed. However, it was put up for sale in 1973 and went into voluntary liquidation. All of the creditors were paid, leaving a surplus of £58,293 that was distributed to the shareholders. At the end of 1973, the camp was sold to Howstrake Holiday Village Limited and three years later, the owner of the Alexandra Hotel at Douglas took over the site. Over the following years, various rumours were circulated regarding the sale of the complex, but on 21 July 1980 several of the buildings were damaged by a major fire at the site, and it was sold to Fontenay Limited in 1981, who promised to invest £3 million to improve the facilities. Nothing positive came of any of these proposals and the site deteriorated until an application was made in 1994 for the construction of 200 houses and flats. The planning application was refused.

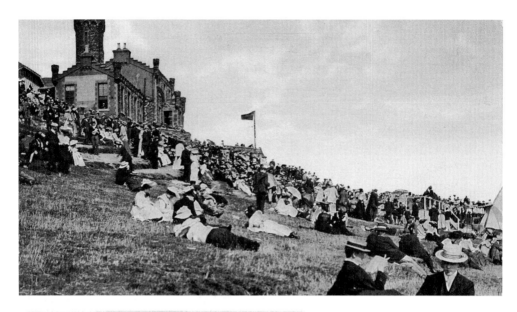

Above: Hospital Sunday with the bishop preaching on Douglas Head in the early years of the twentieth century.

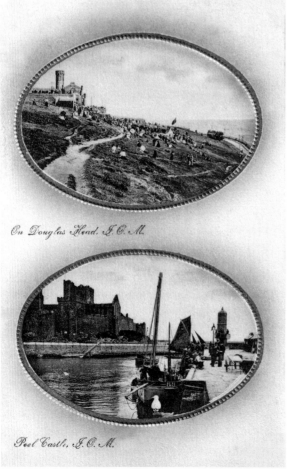

On Douglas Head. I.O.M.

Peel Castle. I.O.M.

Left: Douglas Head and Peel Castle.

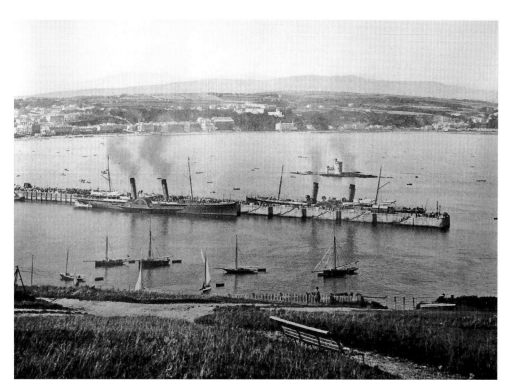

The Harbour from Douglas Head. The steamer bound for Liverpool loads passengers on the outside of Victoria Pier as a Steam Packet paddle steamer brings passengers to the Island.

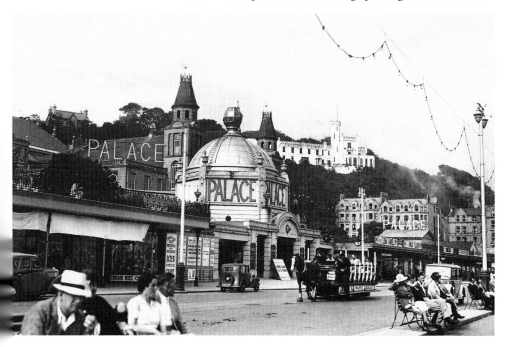

The Palace Theatre, Douglas.

Advertisements for The Palace, 1923. The Palace is one of the main dancing halls in Douglas. It was partly burnt down in 1902, but was rebuilt before suffering another serious fire in 1920. The building was again rebuilt, refurbished and reopened in July the following year. The dance floor is 16,000 square feet and accommodates a thousand couples at a time. One of the features of the entertainment was the shadow dance where confetti was poured down from the roof and coloured lights were turned on, shining in the direction of the dancers. The hall has seating for over 5,000 people and over 7,000 people attended a Palace Sacred Concert following its opening. This concert was held on a Sunday and included opera and oratorio. The Coliseum adjoins the ballroom. It is a variety theatre that was opened in 1913, and can seat 3,500 people.

Advertisement for entertainment at Derby Castle, 1923.

Anti-litter campaign poster, 1985.

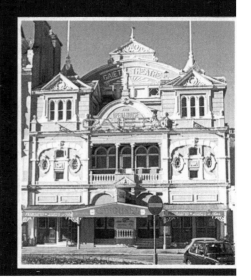

The Gaiety Theatre opened on 16 July 1900. It was formally the Marine Pavilion and was converted to a theatre by Palace Coliseum and Derby Castle theatres. The theatre was designed by Frank Matcham, who had a reputation as being 'The King of Theatre Architects' and was also responsible for the Winter Gardens at Blackpool.

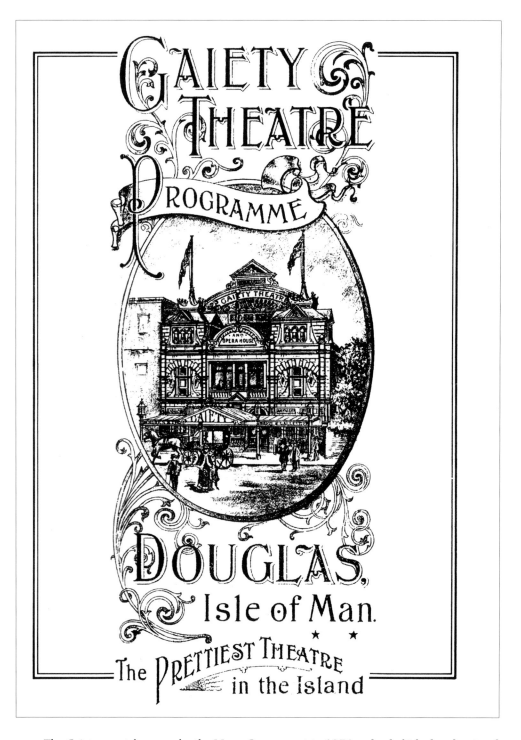

GAIETY THEATRE
PROGRAMME

DOUGLAS,
Isle of Man.
★ ★
The PRETTIEST THEATRE
in the Island

The Gaiety was taken over by the Manx Government in 1976 and refurbished and restored to its original form. It continued to provide entertainment shows, drama festivals, operatic productions, pantomimes and concerts.

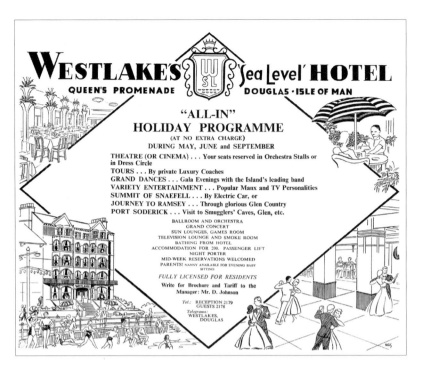

Westlake's 'Sea Level' Hotel's 'All-In' holiday programme advertisement for the 1960 season.

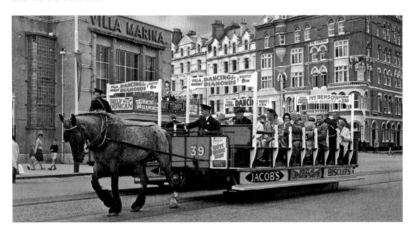

A horse-drawn tram passes the Villa Marina in the 1960s. The horse trams were the idea of Thomas Lightfoot who had retired from Sheffield to a villa at the north end of the bay. When the Loch Promenade was opened he decided to construct a tramway and work commenced on the project in June 1876. The first line from the bottom of Summerhill to Broadway opened two months later and plans were made to extend it to the Victoria Pier. The tramway was sold to the Isle of Man Tramway Limited in 1882 and a double track was completed by 1889, with an extension to the Derby Castle Ballroom and Theatre. There were twenty-six cars in service in 1891 and most of the vehicles were constructed by Starbuck's, which later became Milne's at Birkenhead.

Where to go in Douglas

ENTERTAINMENTS AND ATTRACTIONS
PROVIDED BY THE DOUGLAS CORPORATION

VILLA MARINA

ROYAL HALL, GARDENS, BOWLS, PUTTING
Open daily during Season
DANCING—Nightly in Royal Hall.
GARDEN CONCERTS—Daily at 3.0 p.m.
BATHING BEAUTY COMPETITION
every Thursday afternoon
SUNDAY EVENING CELEBRITY CONCERTS IN
ROYAL HALL.
OPEN BOWLING TOURNAMENT in June
100 guinea cup and other prizes.
LADIES OPEN BOWLING TOURNAMENT also in June
valuable prizes.
HIGH CLASS RESTAURANT.

PULROSE GOLF COURSE (18 holes)

The finest course on the Island. Beautiful surroundings.
Clubs may be hired from the Professional.

NOBLE'S PARK PLAYING FIELDS

TENNIS, BOWLS, GOLF
18 Tennis Courts (Grass and Hard).
2 Crown Greens and Putting Green.
9-Hole Miniature Golf Course.
OPEN DAILY. LIGHT REFRESHMENTS.

DOUGLAS HEAD

DOUGLAS HEAD SWANEE MINSTRELS
Daily Shows—11 a.m. and 3.0 p.m.

BATHS — VICTORIA STREET

Luxurious Sea Water, Foam and Medicinal Baths.
Mixed Bathing Sea Water Swimming Baths.

SUMMER HILL GLEN (North end of the Promenade)

GLEN FALCON (At the foot of Broadway)

Natural Beauty Spots—Admission Free.

DOUGLAS GUIDE BOOK—Issued Free on Application to
Town Clerk, Dept. I.G., Douglas.

In the 1980s, the service required around sixty-five horses to operate with each horse working an average 'tour' of four complete journeys a day, with the older horses completing six journeys at night. The trip along the 2 miles of the route takes around twenty minutes at an average of 6mph. The Villa Marina had an extensive list of entertainment and attractions including dancing, concerts, bowling tournaments and a 'high class restaurant' for dining.

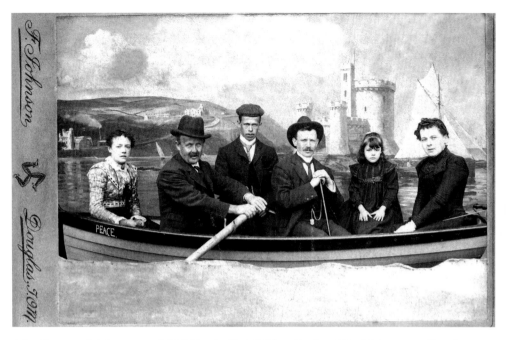

A family portrait taken around 1910 in the Fort William Studio of Fred Johnson on Douglas Head Road. They also operated Express Bridge and Battery Studios in Douglas. The picture states that, 'Additional copies may always be had. This picture can be enlarged to any size and finished in oil, water colour & crayon.'

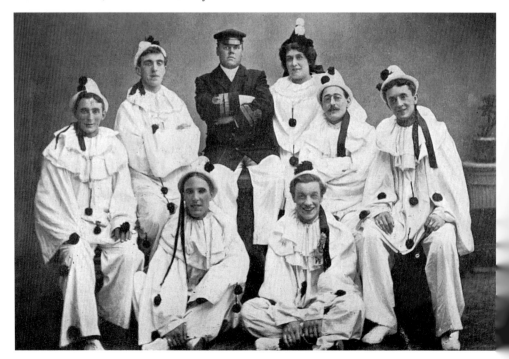

Buxton's Pierrots at The Bandstand on Douglas Promenade, 1904.

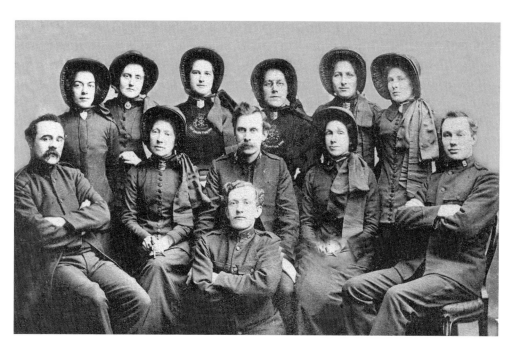

Major and Mrs Cloud, Adj Frith and officers of the Isle of Man Salvation Army. The Salvation Army was founded in East London by William Booth in 1865. It is one of the largest and most diverse providers of social services in the United Kingdom. The corps and community centres provide services centred round a belief that disadvantaged people are given respect and access to the practical, social and spiritual support they need to realise their potential and recover their personal dignity. The Salvation Army now works in 124 countries offering help to those in need. At the time that this photograph was taken, the Salvation Army had corps at Douglas, Ramsey, Peel and Laxey.

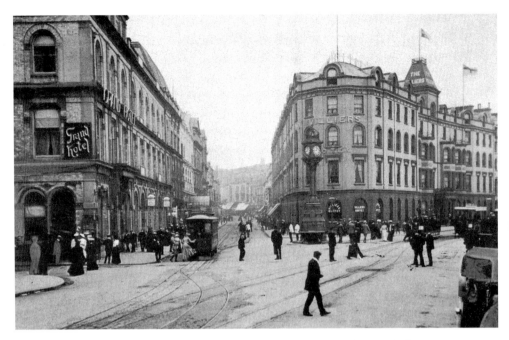

Victoria Street, Douglas leads up from the promenade to the shops, offices and administration centre of the capital. When Douglas was a popular holiday destination this area was very busy on summer nights, with many people enjoying its numerous bars and public houses. The town and promenade were often exposed to the strong winds and gales that are prevalent in the Irish Sea during the winter months. Most of these only lasted a few days but could cause flooding and closure of the promenade, disrupting local transport services and depositing branches, litter and other items across the main promenade.

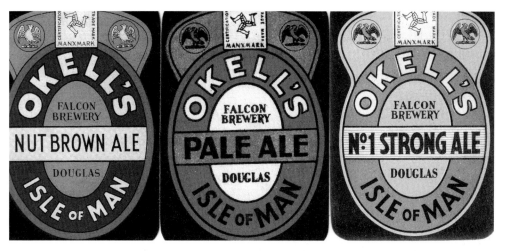

Okells Brewery beer mats. A Cheshire surgeon, Dr William Okell was responsible for opening Okells Brewery in Castle Street, Douglas in 1850. He had purchased most of the pubs on the Island by 1874 and lobbied Tynwald to pass an Act to ensure the purity of the beer brewed when he built The Falcon Steam Brewery. He used steam to boil the brewery coppers instead of the usual means of a direct coal fire. The use of steam meant that there was less charring and caramelisation of the sugars during the boiling process. This brewery continued until 1994 when the last brew was mixed on 18 August that year. The new brewery was opened at Kewaigue on 12 January 1996 by the chief minister and its core production is Okells Bitter and Okells Mild, which have both won awards in the United Kingdom and Europe over the years.

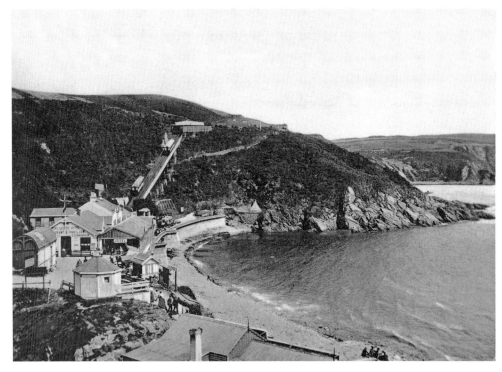

Port Soderick is on the south of Douglas and was reached by motor boat from Douglas Harbour, or by train. There is also a footpath via Kewaigue and the Fairy Bridge.

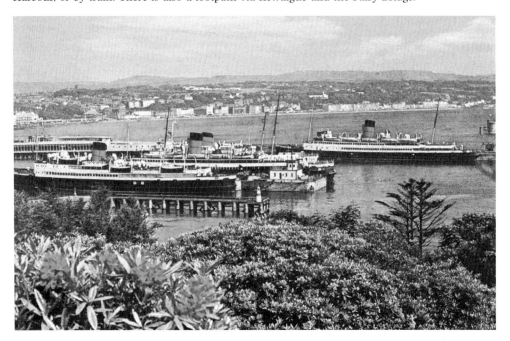

Most of the fleet of the Isle of Man Steam Packet is berthed in Douglas Harbour on a summer Sunday morning.

2

RAMSEY

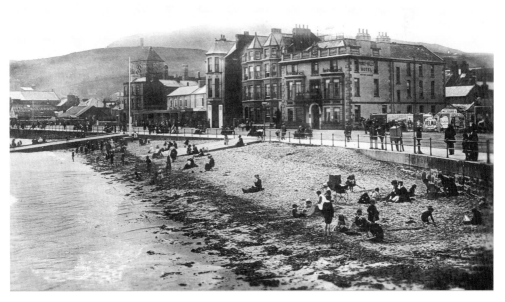

The beach at Ramsey was always regarded as a quiet alternative to the busy beaches of Douglas.

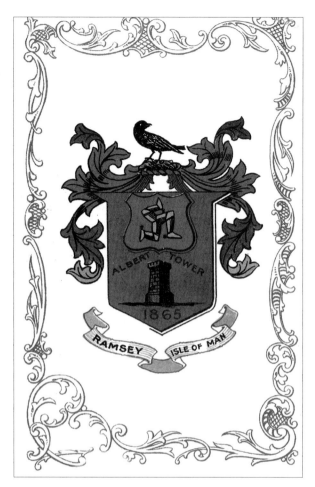

Ramsey Coat of Arms. The town has been the site of many battles. Godred Crovan fought on Sky Hill around 1079 and his son Olaf fought in a conference with his nephew Rognvald in 1152. Several years later, Somerled arrived in Ramsey Bay with sixty ships and fought a battle with Godred II. It is recorded that a fleet of 100 warships anchored in Ramsey Bay, under Rognvald on his way to fight in Ireland. Robert Bruce arrived at Ramsey with his troops and they marched down the coast to Castle Rushen, which they invaded.

Dukenfield brought the Parliamentary forces to Ramsey Bay for the Commonwealth to take over the island. William III and his fleet anchored in the Bay on his way to Ireland for the Battle of the Boyne and one of the ships ran aground on what is still known as King William's Bank. The Frenchman Thurot invaded Carrickfergus, with a fleet of five ships and 1,700 men. After losing two of his ships, he was followed by three English frigates that captured the remaining French ships in Ramsey Bay, after Thurot was shot.

The pier at Ramsey is 2,300ft long and cost over £80,000 to build. In 1902, King Edward VII and Queen Alexandra came ashore onto the pier, reinforcing the title of Royal Ramsey that the town has held for over 1,000 years when Godred Crovan landed in 1079. When Ramsey was declared a town in 1865, shipbuilding was an important industry and the yard built different types of vessels, including the *Star of India*, which is now a floating exhibit at the Maritime Museum of San Diego, California. Ramsey is also the market town for the agricultural community in the north of the Island.

So delightfully different

RAMSEY

A seaside haven of beauty and great variety, with miles of safe, sandy shores, ideal for bathing.

Unsurpassed for the family holiday.

Restful and health-giving with every form of recreation and outdoor sports within easy reach.

Park and Marine Lake with yachts, canoes, rowing and motor boats, and visitors' regattas.

Tennis. Golf (18 holes), ideal for the holiday maker, miniature links and putting greens. Children's Playgrounds.

Open-air swimming pool — galas throughout the Season and beauty competitions.

Bowls — two excellent greens in beautiful surroundings

Angling (sea and river). Local club arranges visitors' competitions.

Ramsey provides many outstanding vantage points for viewing the T.T. motor cycle races in June and September also the June cycle T.T. races (massed start).

Two modern cinemas and a beautiful ballroom — dancing every evening.

Nestling in the foothills of North Barrule with glens and walks galore, a climate mild and invigorating completes the picture of where you will find all that provides the healthy body and contented mind.

++++++++

WHERE TO STAY IN RAMSEY

Illustrated literature and Accommodation List can be had free on application to Secretary, Publicity Dept., Dept. B, Ramsey.

Advertisement for Ramsey, 1953.

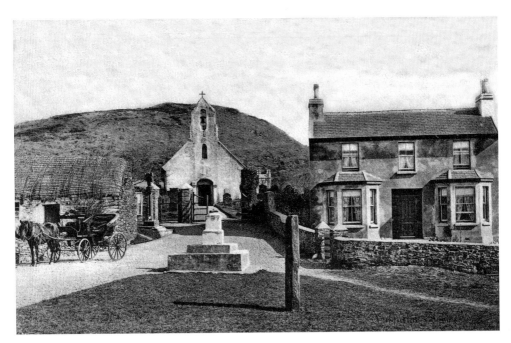

Maughold Church and runic cross, in 1900. Saint Maughold or 'Machutus', was an Irish prince, and captain of a band of thieves. He was converted to Christianity by Saint Patrick. Legend states that he was placed in a coracle by Saint Patrick and he came to the Isle of Man to avoid temptation. Romuil and Conindri, who were two disciples of Patrick, were already established on the Island. The village of Maughold is on the coast, 3 miles from Ramsey and the parish includes most of North Barrule, which is the second highest hill on the Isle of Man. There are a number of important Celtic crosses in the area and it is thought that it was the site of an early Christian monastery.

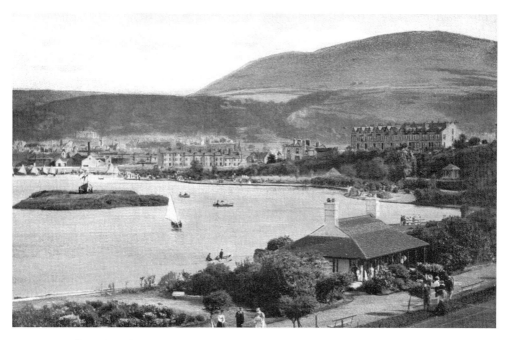

Mooragh Park and its lake in Ramsey. The Ramsey town commissioners bought a 200-acre tidal swamp in 1881. It cost £1,200 and they intended to build the site into a leisure park. It was opened to the public six years later, proving to be a great success and a welcome addition to the facilities provided in the town. It has 5 hectares, a 12-acre boating lake, tennis courts, children's play area, BMX track, bowling green, crazy golf, gardens, café and an outside adult exercise area with suitable equipment.

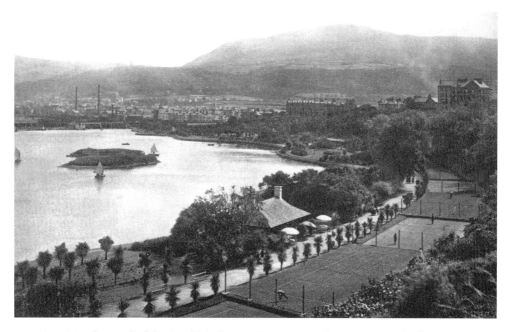

A quieter day at the lake in which the tennis courts can be seen more clearly.

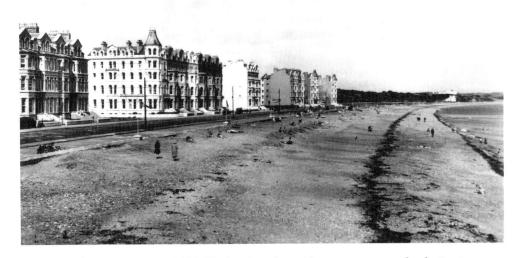

The North Shore at Ramsey, in 1953. The hotels and guest houses were a popular destination for holidaymakers who preferred the quieter atmosphere of Ramsey. The South Promenade, slightly further down, also consists of a variety of houses built in various styles and sizes. The sea wall here is 5ft thick and 15ft high from the foundations.

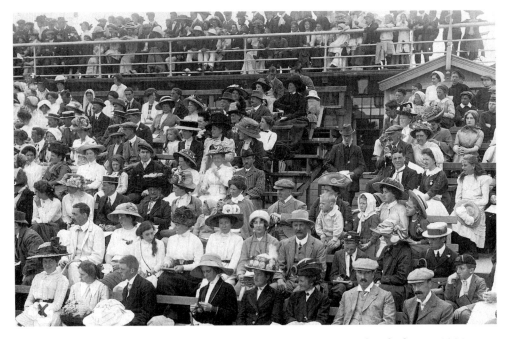

Ramsey Gala in 1911. It was once held every year, but the last carnival took place in 1990.

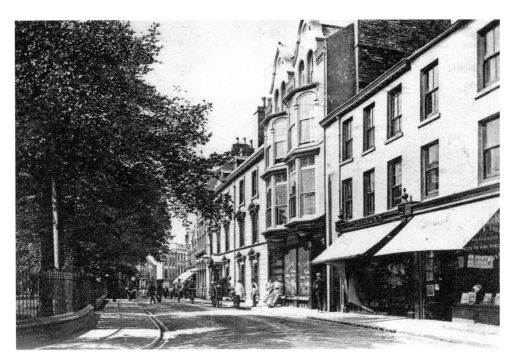

Parliament Street, Ramsey. Ward Lock describes Parliament Square as, 'The chief business thoroughfare'. He observed that:

Ramsey has plenty of shops, and good ones too. The Public Offices, in the Elizabethan style, are at the junction of Parliament Street with that leading to the Railway station. Near the other end stands the Court House, in splendid isolation. In the grounds is the local War Memorial, a Manx Cross fashioned in red sandstone from Woolton, similar to that used in the construction of the Lady Chapel of Liverpool Cathedral. The Post Office faces one side of the Court House green, the Mitre Hotel another. Close at hand is the Masonic Hall. The road makes a sharp bend and we have on the right the Palace cinema. Part of the building is used as a licensed dining hall by the Electric Railway Company. A pleasant square, dotted with kiosks and shelters, serves as the Electric Railway Station.

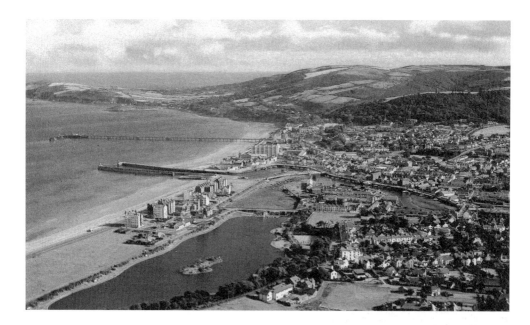

Above and below: Ramsey from the air. On the 20 September 1847, Queen Victoria and Prince Albert arrived unexpectedly in Ramsey Bay on the royal yacht. Suffering from seasickness the Queen remained onboard, but Prince Albert went ashore and travelled from the yacht to the beach by one of the vessel's small boats. It was reported that he was met by a local barber who took him to the hill overlooking the town. The townspeople of Ramsey later erected the Albert Tower on the hill.

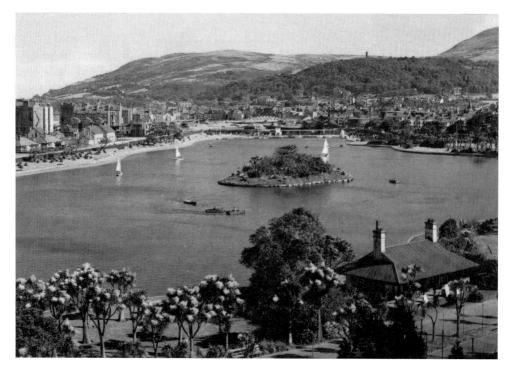

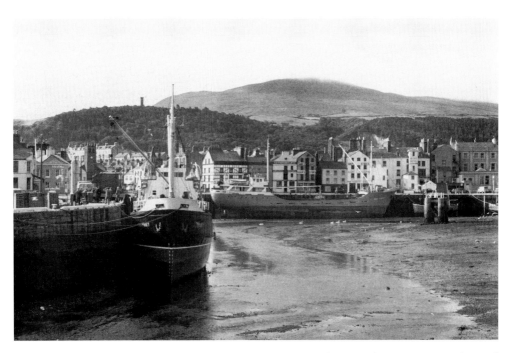

The Harbour at Ramsey in 1965, with steamers from the Isle of Man Steam Packet and Ramsey Steam Ship companies loading cargo at the quays.

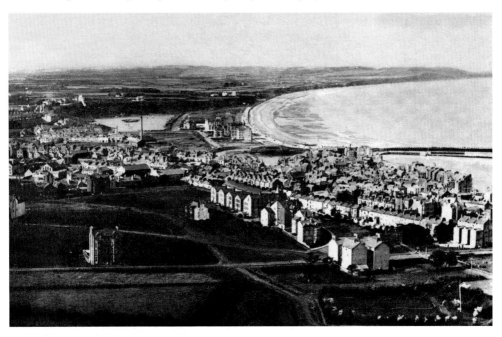

Ramsey town and beach. Ramsey is divided into two parts by the river and the harbour. To the north it is mostly modern and the town is to the south situated between the quay and the promenade.

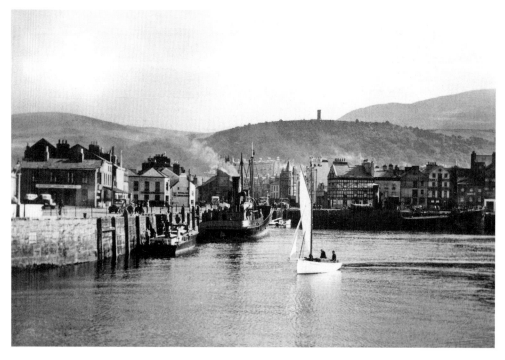

A yacht sails across a tranquil Ramsey Harbour in the soft evening sunlight.

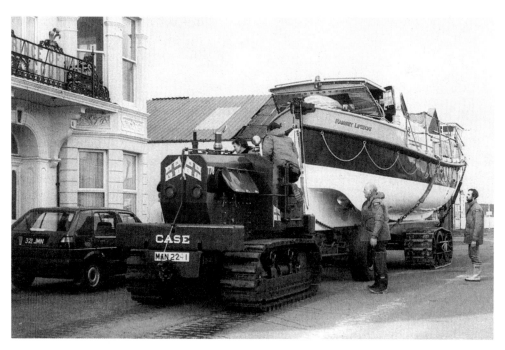

The 37-foot Oakley-class lifeboat, the *James Ball Ritchie*, returns from an exercise on 25 February 1989. The vessel was built in 1970 and has twin Ford 52 hip (Hubbards Impala Parts) engines capable of a speed of over 8 knots. (*Courtesy of Mannin Collections Ltd*)

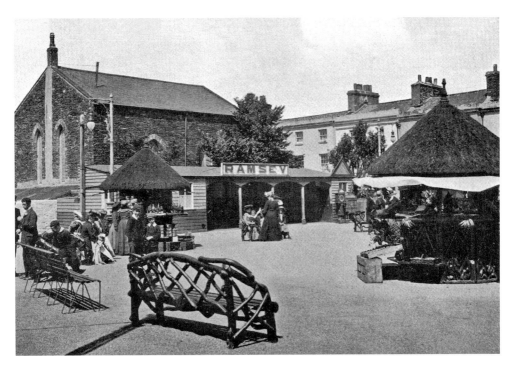

Ramsey Station in 1906.

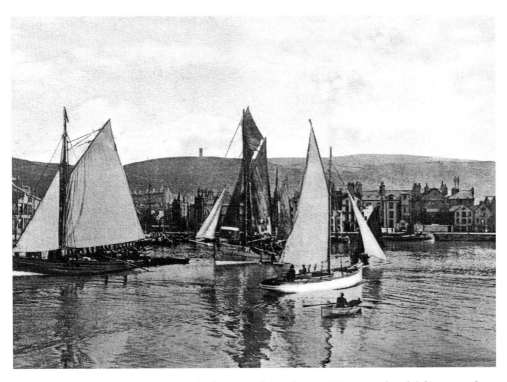

Ramsey Harbour in 1913. The harbour is tidal and is used by coastal and fishing vessels.

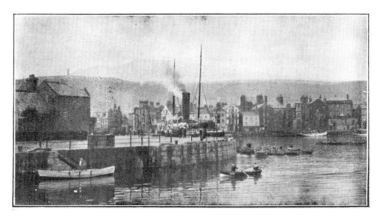
Ramsey advertisement from 1937 offering, 'Rest, Recreation and Recuperation and everything for the Ideal Outdoor Holiday, Sandy Shores, Glorious Glens, Summer Sports.'

Advertisements for hotels in Ramsey from 1954.

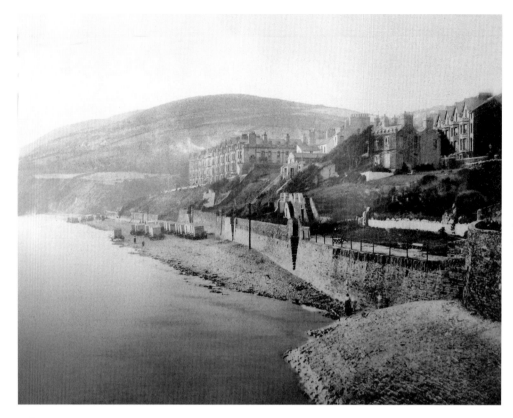

Ballower Mount at Ramsey in 1900, with swimmers emerging from the bathing huts parked on the beach.

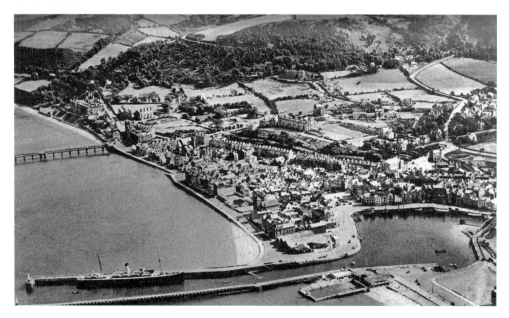

Ramsey from the air in 1936.

3

PEEL

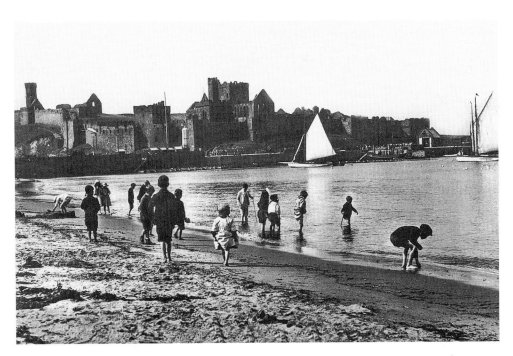

Peel Castle and shore at the forefront of the photograph. At the end of the nineteenth century, fishing was the main industry and ships were built at Peel. There were over 300 fishing boats employed from the port in 1880, but this number had declined dramatically by 1915. When the railway was completed in 1873, Peel developed as a tourist destination, and hotels and boarding houses were built at the seafront. Since the 1960s, tourism on the island has declined but Peel has been able to attract many visitors to its annual Viking Festival.

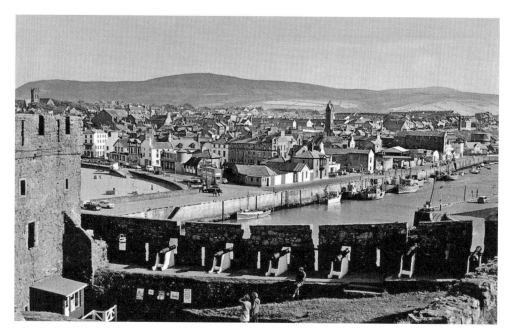

Peel Castle and the harbour.

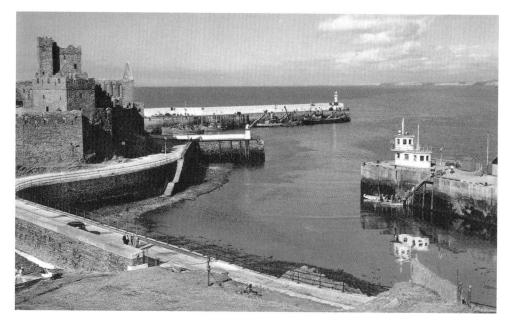

The castle and harbour at Peel. St Patrick's Isle stands at the entrance to the harbour and the only sheltered port on the west coast of the Island. It is claimed that a wooden 'peel' or fortress was erected by Magnus Barefoot on this site following his arrival in 1098. The Kings of Mann are thought to have resided on St Patrick's Isle until the first half of the thirteenth century. King Godred II died there in 1187 as did his son Olaf II in 1237. The red sandstone gate tower was built by Sir William le Scrope in 1392 and the wall was probably constructed around 1500 to defend the island from the Scots and others.

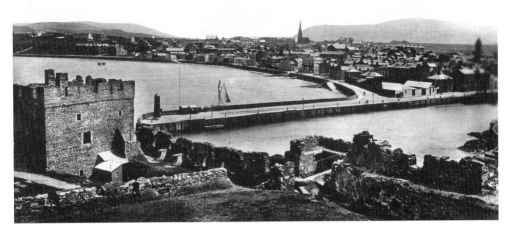

Peel in 1913. Peel is divided into three areas: the narrow streets of the fishing village;
the historic ruins of the castle and cathedral; and the modern holiday district that climbs
from the shore to the summit of the cliffs. It boasts a broad expanse of sandy beach which
stretches from the cliffs on the north to the harbour wall and is flanked by the Marine Parade.
The semi-circular promenade contained hard tennis courts, a bowling green, a playground and
the Marine Hall, where concerts and dancing were held.

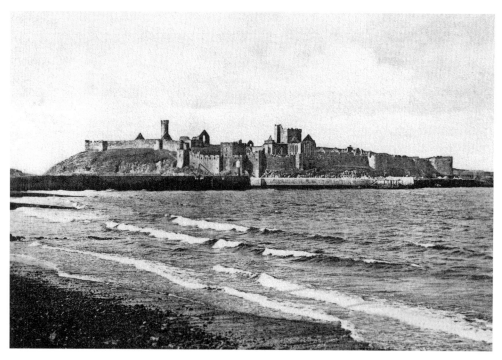

Peel Castle. One of the main features of the castle is the roofless cruciform cathedral of red sandstone, which has a central tower 80ft high and a nave 52ft long. The unusual epitaph to Bishop Rutter, who died in 1662, says in Latin, 'In this house, shared by the little worms, my brothers, I Samuel, by divine permission, Bishop of this island, lie in the hope of a resurrection. Stop, reader, look and smile at this palace of a Bishop.' On the quay, just below the castle is the lifeboat and outside the lifeboat house is the painted figurehead of a Norwegian sailor, which is all that remains of the sailing ship, the *St George*, which was wrecked on the rocks below Fenella's Leap.

4

PORT ERIN

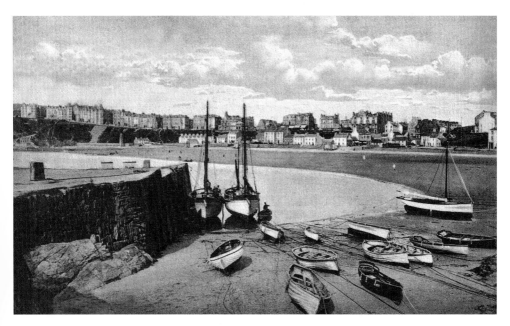

Port Erin offers coast and hill scenery, pleasant walks and facilities for bathing, fishing and boating. The landmark of Milner's Tower on Bradda Head was 'erected by public subscription to William Milner, in grateful acknowledgement of his many charities to the poor of Port Erin, and of his never tiring efforts for the benefit of the Manx fishermen'. William Milner was a safe maker from Liverpool and the tower represents a key. It was built in 1871 by public conscription. Port Erin is a popular base for fishermen and walkers to Bradda Head. The Marine Biological Station and Aquarium was established in 1902 and control was transferred to the University of Liverpool in 1919.

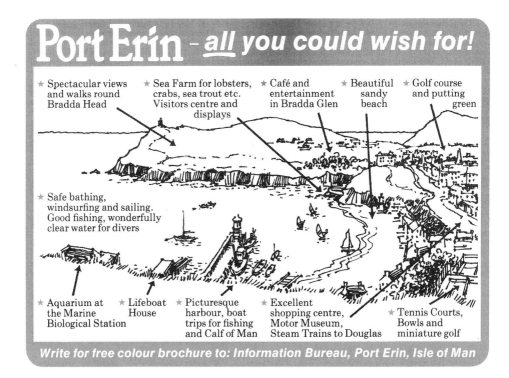

Port Erin advertisement of 1985.

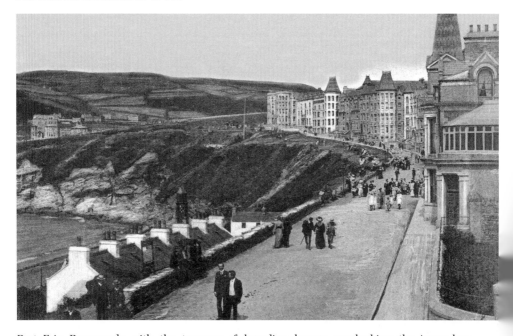

Port Erin Promenade with the terraces of boarding houses overlooking the inner bay. The square-shaped bay is formed by Bradda Head and the Mull Hills, which divide the town from its neighbour, Port St Mary.

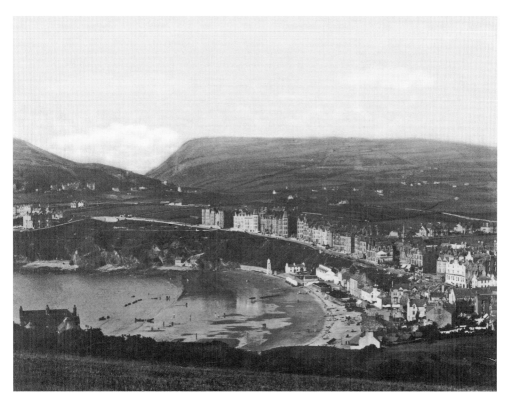

Port Erin in 1927. The promenade runs along the south side of the bay over to the harbour, where boats are hired for fishing trips and pleasure cruises to the Calf of Man and bird sanctuary.

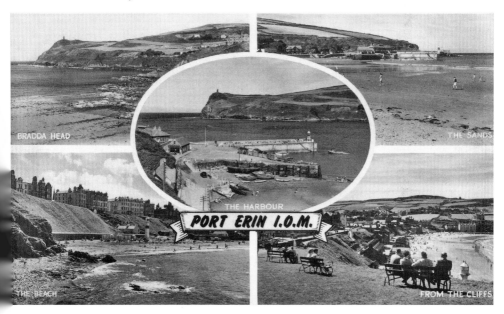

Multi-view card of Port Erin dated 31 May 1962.

PORT ERIN

BELLE VUE HOTEL

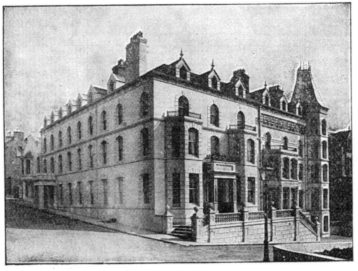

FALCON'S NEST HOTEL

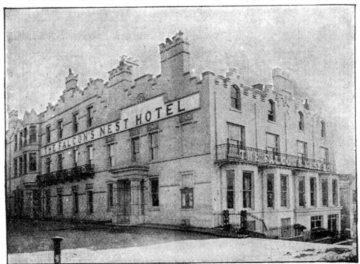

MODERATE TARIFF **Excellent Golfing Links**
Apply for Terms to the MANAGERESS at the respective Hotels

Port Erin advertisement of 1923.

5

PORT ST MARY

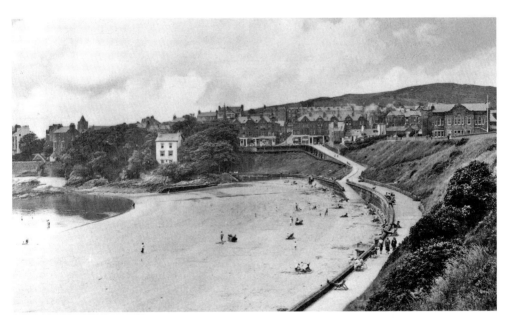

The oldest part of the town is situated around the harbour and has become a centre for yachting. The breakwater gives good shelter to vessels in the harbour. The Alfred Pier was named after the previous Duke of Edinburgh in 1882. The location is popular with walkers who take advantage of the beautiful scenery between Port St Mary and the Calf of Man, passing the Chasms. Boating excursions are also provided to the Fairy Caves and The Hall, the Sugar Loaf Rock and the Chasms.

The tennis courts at Port St Mary. They consist of seven grass and three hard courts, there is also a miniature golf course and putting green with eighteen holes. They are very popular with the holidaymakers in the summer months and especially following the Wimbledon fortnight.

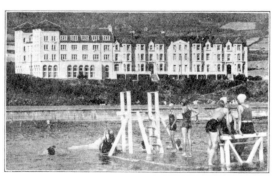
Advertisement for Balqueen Hydro at Port St Mary.

Advertisements for Kneale's Garage, Athol Street, Port St Mary. Kneale's provided a taxi service to meet you at the boat and take you, your family and luggage back to Douglas at the end of your holiday. They provided cars to take you anywhere on the Island and were also motor, marine and general engineers.

Port St Mary advertisement.

6

CASTLETOWN

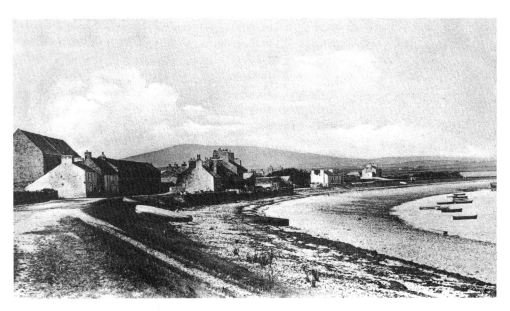

Derbyhaven, near Castletown. At the beginning of the twentieth century, Derbyhaven was a picturesque hamlet with forty to fifty houses scattered around the bay. It is mentioned in Hesba Stretton's *The Fishers of Derbyhaven* and T.E Brown's *Betsy Lee*. At that time, there was a small, buttressed mission room on the road to Castletown. Derbyhaven is popular with golfers since the opening of the Castletown Golf Links. The old farmhouse of Ronaldsway was the ancestral home of William Christian, who was shot on Hangohill in 1663. Derby Fort was built by the 7th Earl of Derby in 1645, and the remains of the twelfth-century chapel can be seen on St Michael's Isle, which is linked to Langness by a short causeway and forms the southern horn of Derbyhaven.

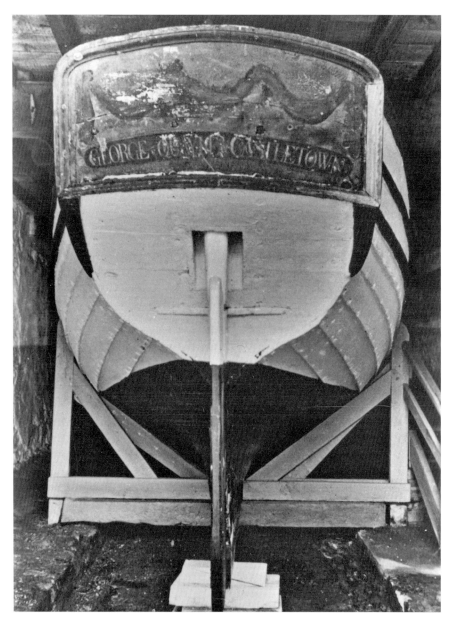

Peggy of Castletown was built around 1790, locally for the Admiralty. This area of the Irish Sea was used by French privateers to attack shipping trading between Liverpool, Bristol and Belfast. She is a schooner-rigged clinker-built, two-masted vessel, with a gaff mainsail and a jib and was fitted with eight small cannons. She has an elm keel, her timbers are of pine and her frames and floors are of oak. She was owned by Captain George Quayle, who was captain commandant of the Manx Yeomanry during the Napoleonic period. He was a member of the House of Keys and together with his brother Mark, founded the Isle of Man Bank. The bank opened in 1802 and when it closed in 1818, George Quayle sold his estate and the Barony of St Trinians so that he could buy and honour all of the notes in circulation. The boathouse is fitted at the stern quarter of the ship.

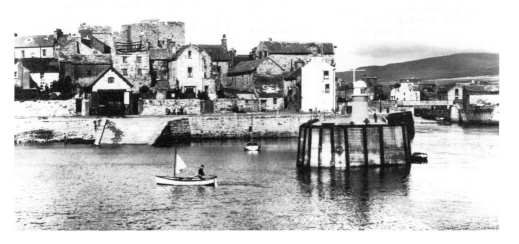

The harbour. Castletown stands in the middle of a piece of coast and a unique formation of Carboniferous limestone. Its houses, castle harbour walls and breakwater are built of the grey stone, giving its distinct appearance.

Castletown was the ancient capital of the Kings of Mann and was known as Ballacashtal and later Rushen. It is situated on the northwest side of Castletown Bay opposite the Langness Peninsula and Derbyhaven. Castle Rushen stands in the Market Square to the south east and the harbour to the north east. The oldest part of the castle was built in 1190 by Godred II. Robert the Bruce captured the castle in 1313 and the tower was enlarged in 1340 under Edward III. A curtain wall was added, a glacis and outer wall were built around 1550. The seventh Earl of Derby built a residence in 1644, within the surrounding wall. The one hand clock is believed to have been donated by Queen Elizabeth the first and it bears her monogram.

The 10th Earl of Derby lived in the castle in the early part of the eighteenth century and until 1891 it became the island's prison. Castletown Church was built as a garrison chapel on the site of an older church. It contains two candlesticks which were presented by Margaret Quilliam, the widow of Captain John Quilliam, who was Nelson's quartermaster on the Victory at the Battle of Trafalgar. Colonel Cornelius Smelt, who was Governor between 1805 and 1832 was remembered by the erection of the Smelt Memorial, the Column in the market square.

Advertisement for Castletown Golf Links & Hotel.

7

LAXEY

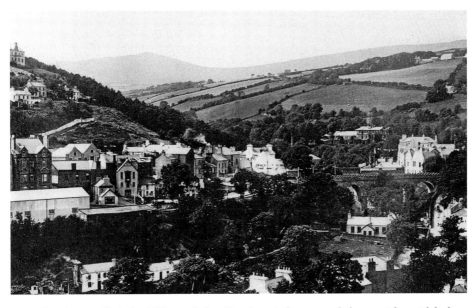

Laxey has been called the 'Village of the Glens', as it has two of the most beautiful glens on the Island that come down from the slopes of Snaefell to join within a mile of the coast, and form a wide valley running down to the sea. The Laxey River and Glen Roy are both popular with anglers, and many unusual ferns and flowers are found in Agneish Glen. A mile-long walk takes you down the valley to the harbour. There are various sporting and leisure facilities available and a recreational ground was built as a gift of the Noble Trustees. 'Laxa' means 'salmon water', but one is unlikely to catch the fish in the streams around the town. The mines at Laxey were worked for many years and they extend to a depth of around 1,800ft. A panoramic view of the glen is obtained from the Laxey Glen Gardens. The mill at Laxey was founded in 1881 by John Ruskin, who was an Oxford scholar and artist. The looms were installed in a former corn mill and it is famous for its range of Manx tweeds.

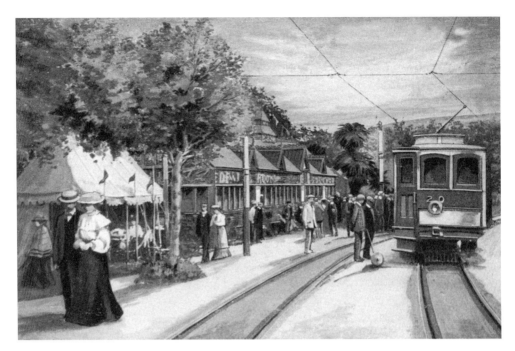

Laxey Electric Tram Station. In his guide to the Isle of Man, Ward Lock felt that the part of Laxey next to the station was more attractive than the old town. He wrote that:

> By no means the least pleasant feature is the station itself. Would that all junctions and waiting places boasted the same amenities. Tall trees, neighbours to the sky surround the enclosure. The spacious triangular grass plot is dotted with rustic seats and arbours, and tempting wares in the shape of fruit and confectionery are exposed for sale in pavilions and kiosks.

Laxey Church stands near to the station and directly below are the washing floors of the lead mines.

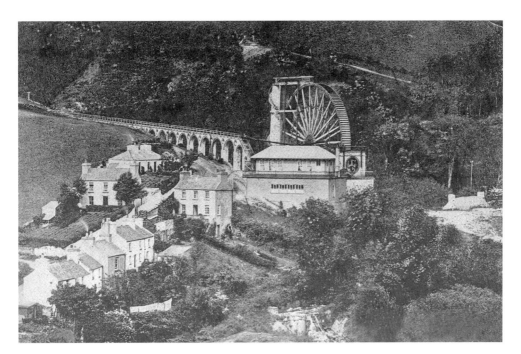

Laxey Wheel from the Mountain Railway. The wheel, named 'Lady Isabella', was built by a local man called John Casement with the purpose of keeping the lead mines free from water. The zinc, copper, silver and lead mines had been in operation for many years and they extended to great depths. The wheel has a circumference of 227ft, a diameter of 72.5ft and a breadth of 6ft. It was designed to raise 250 gallons per minute from a depth of 400 yards. The pumping rods were carried from the wheel on an arched viaduct over 200 yards to the main shaft of the mine. The platform is 75ft from the ground and is reached by a spiral staircase of ninety-five steps.

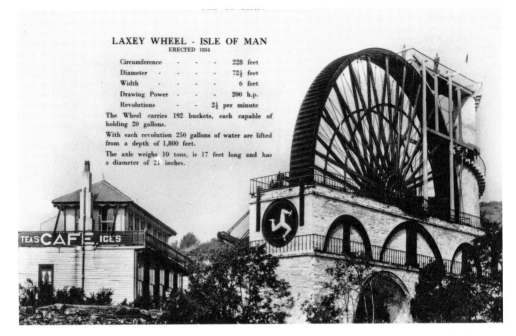

LAXEY WHEEL - ISLE OF MAN
ERECTED 1854

Circumference	-	-	-	228 feet
Diameter	-	-	-	72½ feet
Width	-	-	-	6 feet
Drawing Power	-	-	-	200 h.p.
Revolutions	-	-	2½ per minute	

The Wheel carries 192 buckets, each capable of holding 20 gallons.

With each revolution 250 gallons of water are lifted from a depth of 1,800 feet.

The axle weighs 10 tons, is 17 feet long and has a diameter of 21 inches.

The Laxey Wheel, which was erected in 1854. In 1911 Laxey was described as 'a little manufacturing village, though it be very attractive to the visitor. New Laxey is prettily built; old Laxey has picturesque old houses; and if the Laxey River is discoloured with lead, a mile down the valley are the harbour and the open sea. The Big Wheel is half a mile from the station, and westwards rises the great slope of Snaefell (2,034 ft).'

8

TRAINS, BOATS
AND PLANES

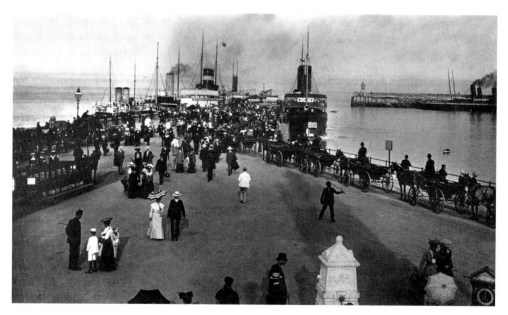

The Isle of Man is situated in the Irish Sea, 16 miles south of Burrow Head in Wigtownshire, 28 miles south-west of St Bees Head in Cumberland, 27 miles east of Strangford Lough and 58 miles north of Holyhead. Consequently, the ships and aircraft that serve the Island from the mainland provide a lifeline service for the Manx community. Transport within the island is provided by a comprehensive network of buses and the Isle of Man and Manx Electric Railway.

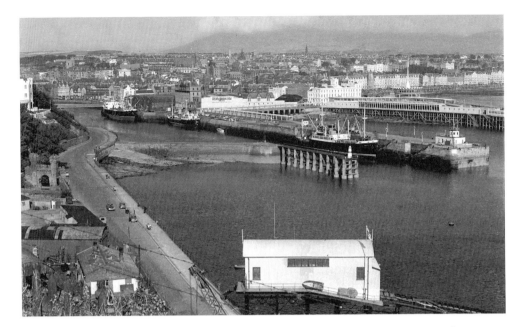

Three Isle of Man Steam Packet cargo vessels loading at Douglas in 1968. *Peveril* was built in 1964 by the Ailsa Shipbuilding Company at Troon, and provided a cargo service from Douglas to Liverpool until she was sold in 1981 and renamed *Nadalena H*. She was scrapped in Turkey in 2001. *Ramsey* was also built by the Ailsa Shipbuilding Company and operated on the company's services until she was sold in 1974, becoming *Hoofort*. *Fenella* was built in 1951 at a cost of £163,783 and was launched at Troon on 6 August that year. She was sold to Greek owners in 1973, and caught fire and sank in the Mediterranean on 2 February 1978.

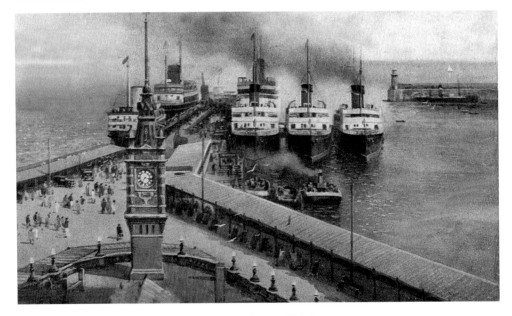

Isle of Man Steam Packet steamers at Victoria Pier in 1934.

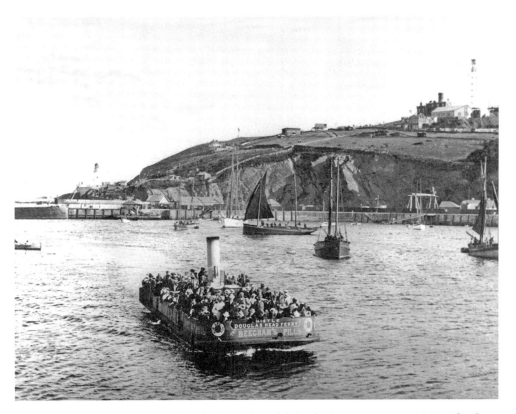

The Douglas Head ferry, the *Thistle*, with a full load of passengers in 1900. The ferry service started two years earlier with the formation of the Douglas Head Ferry Company, which was owned by Laurence Boni and R. Knox. The original fare was 1*d*, which increased to 3*d* by the 1920s. The three ferries, the *Rose*, *Thistle* and *Shamrock* were moved to Castletown at the beginning of the Second World War, but were later transferred to Belfast Lough where they were used to train seafarers in the use of landing craft and simulated beach landings. When they were again returned to Castletown, the *Thistle* resumed service at Douglas in 1948, *Rose* was used as a landing stage before re-entering service in 1949, the *Shamrock* was used to provide spares and the service continued until 1950, when *Thistle* was sold to Pembrokeshire County Council. However, she sank on the voyage to Milford Haven and the Douglas Steam Ferry Company went into liquidation later that year. *Rose* was sold and following the installation of a diesel engine, she returned to the ferry service in 1951 and survived until the end of the decade, when the service was withdrawn. Many people can remember the party atmosphere on the ferries when entertainment was provided by musicians and a pianist. Ward Lock described the ferry service shortly after it had commenced:

> The conveyance of people to Douglas Head every morning necessitates the employment of a small fleet of steam ferries, each capable of holding a hundred or more. These vessels cross every five minutes from the Victoria Pier to the Battery Pier, immediately beneath Douglas Head, saving a long detour by way of the Swing Bridge. The fare is exclusive of the collections made by the musicians on board whose services are apparently as indispensable as those of the captain and the crew. Numerous rowing boats also make the trip.

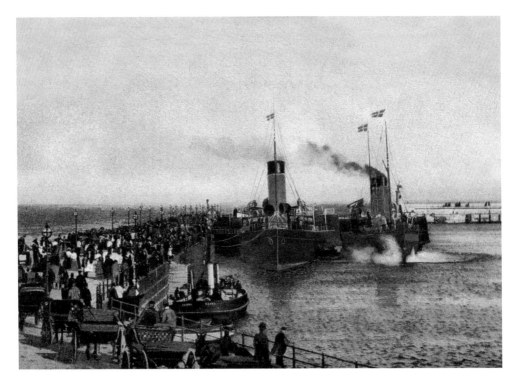

A steamer arrives at the Victoria Pier in 1904. The photograph was probably taken on a busy summer Saturday as visitors pour off the steamer from Liverpool and head along Victoria Pier to the horse-drawn carriages, which are waiting to take them to their hotels and boarding houses.

You see this Beautiful Island to Advantage and at Little Cost When you travel

by

TRAIN

or

by

BUS

ISLE OF MAN RAILWAY
ISLE OF MAN ROAD SERVICES LTD.

Attractive DAY Tours (including luncheon)

Half-day Tours . . . Evening Tours

Timetables and Literature free on request

Station Buildings, Dept. T.
Douglas, Isle of Man.

A. M. Sheard,
Secretary & Manager.

Advertisement for the Isle of Man Railway and Isle of Man Road Services Limited.

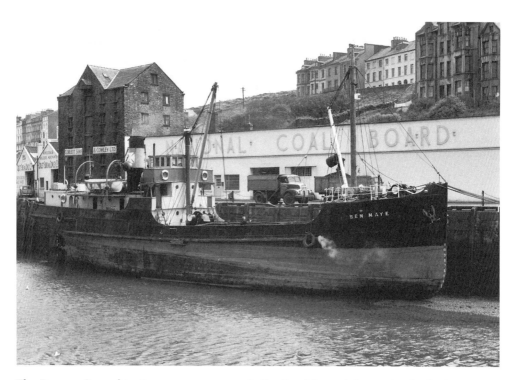

The Ramsey Steamship Company cargo vessel, the *Ben Maye*, at low water in the inner harbour at Douglas. She was built as *Tor Head* in 1921, becoming *Kyle Rhea* in 1935 and was sold to Mrs Emma Cubbin of Douglas in 1940, and purchased by the Ramsey Steamship Company in 1955, becoming *Ben Maye*. She survived until 1964 when she was broken up by W.H Arnott Young & Company at Troon, where she arrived on 15 December that year.

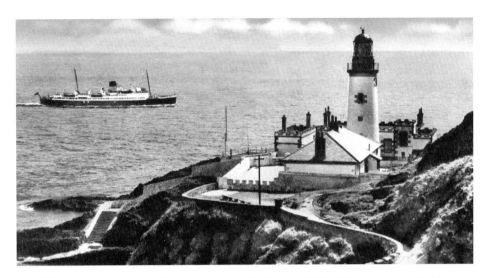

Snaefell passes Douglas Head on a voyage to Dublin in 1953. The voyage to Dublin was described in a booklet issued by the Isle of Man Steam Packet in the 1920s:

Leaving Douglas by one of the large and fast steamers which sail on this route almost daily during the height of the season, we can return the same way and have about three and a half hours for sightseeing in and around Dublin. From Douglas a south-westerly course is steered, and gliding past the Manx shore we review the same interesting coast that is described on our trip, 'Round the Island'. A length the Calf of Man is left behind and we are ploughing away through the blue waters of the Irish Sea, where nothing but the curling waves are to be seen on every hand, with here and there perhaps a lonely fishing smack wending her way along, or a steam trawler trying her luck on one of the sand banks that lie hidden away fathoms beneath the sea.

This part of the Manx coast is described in the 'round the island trip' mentioned above:

After rounding Douglas Head, rugged cliffs extend as far as Port Soderick. Passing closely one precipitous wall after another, we appreciate their height and stern grandeur more clearly than ever before. Opening out Port Soderick Glen, we have a pretty scene, with the finely situated mansion of Crogga in the background. About a mile further south is St Anne's Head, and from thence, going south-westerly, the land recedes to form Derbyhaven Bay. Right ahead, a narrow neck of land runs out far into the sea, called Langness. Near to its extremity we see Fort island, which derives its name from an old stronghold built by James, seventh Earl of Derby. There are also on this Islet the relics of an old mediaeval chapel. At the extreme point of Langness, which is a most dangerous point for shipping, a lighthouse is erected and a salute is given to us as we pass. After passing the Stack of Scarlet, we open out a fine bay. At the furthest extremity is Port St Mary, a favourite resort for artists and families attracted by the boating and bathing facilities. After passing Port St Mary the whole character of the coast is changed into huge headlands, Black Head and Spanish Head being passed in succession. The curious Sugar Loaf Rock should be noted, and the Chasms which penetrate the cliffs beyond. Here we leave the coast of the island proper, and make a circuit of the Calf Islet, which is separated by a narrow rock strewn channel. Away to the left, on the Chickens Rock, is a fine lighthouse, erected at a cost of £100,000.

Advertisements for services to the Isle of Man by the London Midland and Scottish and Great Western Railway, 1937.

Convenient Services and Cheap Facilities

From Principal

GREAT WESTERN RAILWAY STATIONS

to the

ISLE OF MAN

Via BIRKENHEAD

(Connecting with the Douglas Boat at Liverpool Landing Stage)

SPECIAL DAYLIGHT SERVICES

During the Summer.

Breakfast in London ! :: :: Dinner in Douglas !

TIME OCCUPIED
TO
DOUGLAS
FROM

	Hrs.	Mins.		Third Class Monthly Return Fare	
LONDON (PADDINGTON)	9	50	...	47	9
BIRMINGHAM (Snow Hill)	7	45	...	29	5
BRISTOL	10	35	...	43	7
CARDIFF (General)	10	0	...	41	6
CHESTER	5	27	...	16	3
EXETER (St. David's)	16	15	...	56	8
GLOUCESTER	11	45	...	37	0
HEREFORD	8	33	...	32	3
NEWPORT	9	39	...	39	5
PLYMOUTH (North Road)	18	0	...	65	11
SHREWSBURY	6	36	...	23	4
SWANSEA (High Street)	11	15	...	42	6
WOLVERHAMPTON (Low Level)	7	20	...	27	4
WORCESTER (Shrub Hill)	9	18	...	32	0

All details of Train Services, etc., obtainable at G.W.R. Stations and Agencies.

It was possible to book your ticket to the Isle of Man from your local railway station on the Great Western Railway. The main-line train took you to Birkenhead Woodside Station where you crossed the River Mersey to the landing stage at Liverpool and caught the next steamer to Douglas.

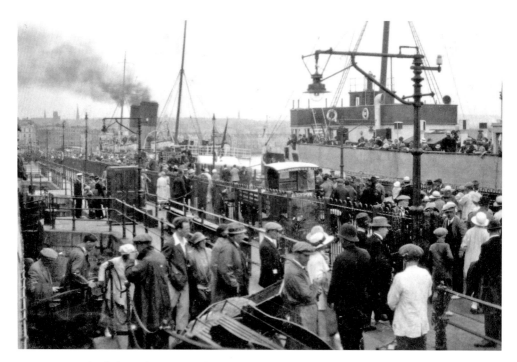

Passengers embark from the Liverpool steamer at Victoria Pier, Douglas after a sea journey from Liverpool. The voyage from the Pier Head at Liverpool took nearly four hours and the steamer sailed past the holiday resort of New Brighton on the Wirral shore and along the channel until it reached the Bar Lightship. This took about an hour and for the rest of the journey passengers could enjoy the sea air, have a meal in the ship's restaurant, or a hot or cold drink on deck.

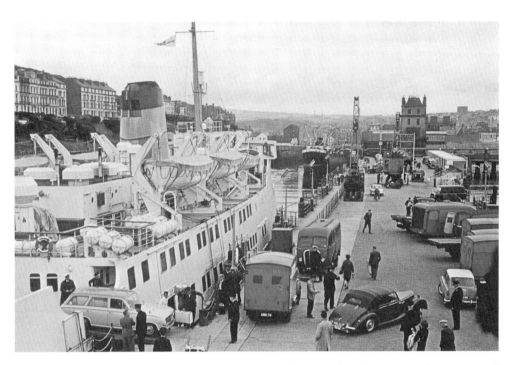

Private cars are driven off the ferry, *Manx Maid*, at the King Edward Pier at Douglas. *Manx Maid* was the Isle of Man Steam Packet's first car ferry and she normally sailed from Liverpool to Douglas. As Douglas is tidal a unique system of ramps were devised for the car ferries which enabled them to load and unload cars at any state of the tide. *Manx Maid* was followed by *Ben my Chree*, *Mona's Queen* and *Lady of Mann* which were all based on the same design.

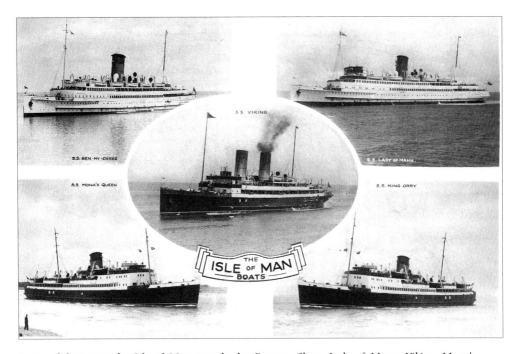

Postcard featuring the Isle of Man vessels the *Ben my Chree, Lady of Mann, Viking, Mona's Queen* and *King Orry*. Postcards were an important part of a British summer holiday as it was felt a duty to send them to relatives and friends to let them know how you were enjoying your vacation. Blank postcards were first sent by post in the middle of the nineteenth century. The first known printed picture card was created in Europe and Britain around 1870 with the 'golden age' of cards in the years following 1890. The boom in holidays in the twentieth century meant that the postcard trade became part of the British seaside industry and many specialist shops opened to cater for the holidaymaker. Postcards of the Steam Packet ships were on sale on the vessels so that passengers could tell their friends and relatives the name of the steamer that transported them over the Irish Sea to Douglas.

Passengers on the bow of the steamer, the *Tynwald*, on a voyage from Liverpool to the Isle of Man in 1969. When the steamer left port and the ropes were stacked it was possible to access the outside area at the bow of the vessel. If the wind was to the stern of the ship deck chairs were brought out and people were able to enjoy the sea air and sunshine.

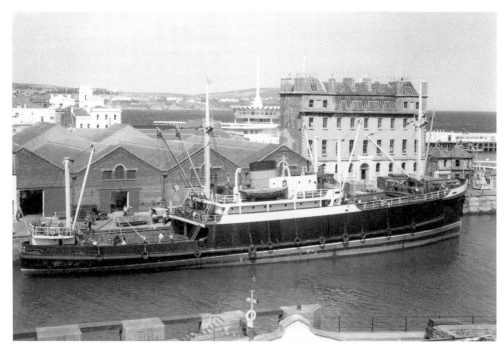

The Isle of Man cargo vessel, the *Fenella*, loading at the company's berth at Douglas.

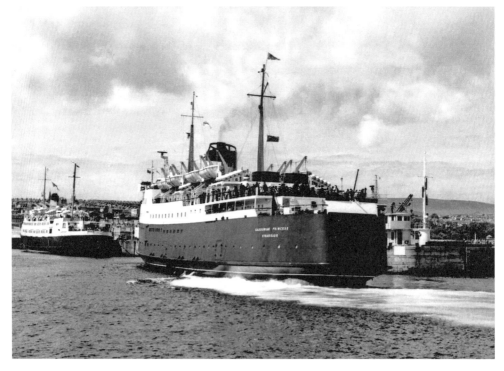

The Caledonian Steam Packet car ferry, the *Caledonian Princess*, arriving at Douglas in June 1967 on a special day excursion from Stranraer.

THREE ROUTES TO THE ISLAND

From LIVERPOOL, 3½ hrs.

From FLEETWOOD, 2¾ hrs.

From HEYSHAM, 3 hrs.

Express Services

By Fast and Luxurious Turbine Steamships.

·LIVERPOOL and DOUGLAS

Sailings each week-day throughout the year.

FLEETWOOD and DOUGLAS

Sailings every week-day during the Season.

HEYSHAM and DOUGLAS

Sailings every week-day during the Season.

Frequent Services also between

DOUGLAS, RAMSEY and BELFAST, DUBLIN
and GLASGOW (*via* ARDROSSAN) during the Season.

If you intend flying to the Isle of Man, travel by Isle of Man Air Services Ltd. Full particulars from principal Railway Stations and Tourist Agencies.

Write for Free Illustrated Guide from

Isle of Man Steam Packet Co. Ltd.

(Incorporated in the Isle of Man) ——————— DOUGLAS

THOS. ORFORD & SON, Agents, Drury Buildings, Water St., Liverpool

Isle of Man Steam Packet advertisement for 1937.

Isle of Man Steam Packet advertisement for 1955.

THE ISLE OF MAN STEAM PACKET COMPANY LIMITED

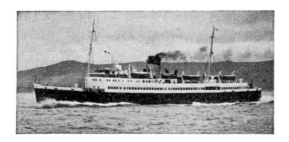

HOW ABOUT A DAY OUT

To LLANDUDNO

ON TYNWALD DAY

Monday, 6th July, 1970

STEAMER LEAVES DOUGLAS 10 a.m.

STEAMER LEAVES LLANDUDNO 6 p.m.

Allowing About 5 Hours Ashore

FARE 30/-

CHILDREN 3 AND UNDER 14
HALF FARE

Tickets may be purchased at Company's Offices, Douglas
and Ramsey, Travel Agents or Booking Office alongside
steamer

Passengers and their accompanied luggage will only be carried subject to the
Company's Standard Conditions of Carriage of Passengers and Passengers' Accompanied
Property as exhibited in the Company's Offices and on board its vessels. Acceptance
of a ticket issued by the Company binds the passenger to these conditions.

P.O. Box 5,
Douglas, Isle of Man.
June 1970.

S. R. SHIMMIN,
General Manager.

Norris Modern Press Ltd., 6 Victoria Street, Douglas

Isle of Man Steam Packet advertisement for Tynwald Day, 1970.

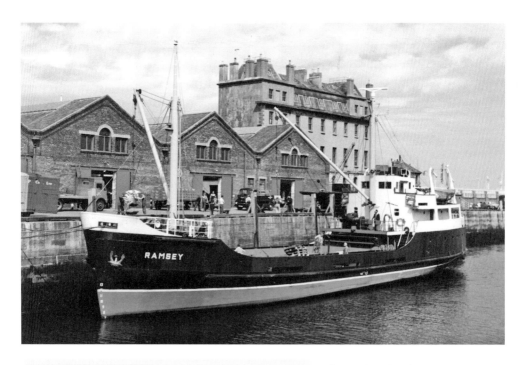

Above: The Isle of Man Steam Packet cargo vessel, the *Ramsey*, loading cargo at the company's berth at the Red Pier at Douglas.

Left: Isle of Man Steam Packet Company map of routes in 1923.

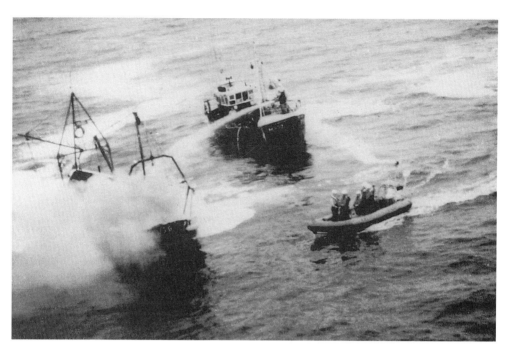

The Atlantic 21-class Peel lifeboat stands by whilst firemen aboard the Milford Haven fishing boat, M357, the *Black Hunter*, attempt to extinguish the fire on the Peel fishing boat, PL56, the *Elizabeth Campbell*, on 11 February 1987. (*Courtesy of Mannin Postcards*)

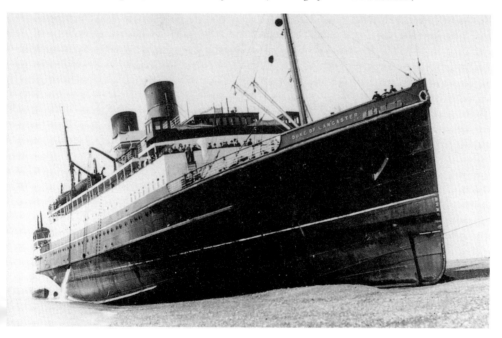

The British Railways passenger vessel, the *Duke of Lancaster*, in thick fog aground near the gravel works at the Point of Ayre on 14 June 1937. She was refloated the next day. (*Courtesy of Mannin Postcards*)

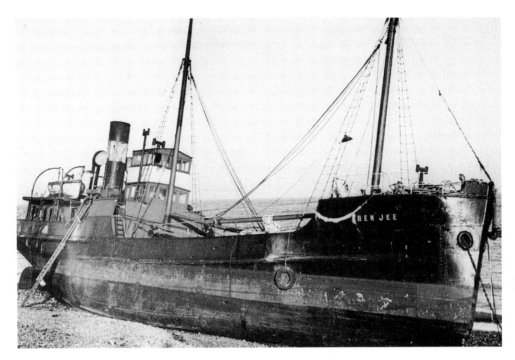

The Ramsey Steamship Company cargo vessel, the *Ben Jee*, also aground near the gravel works at the Point of Ayre on 20 November 1952. She was broken up the following year at Preston. The Ramsey Steamship Company was based in Ramsey and provided cargo services to and from the Island and also traded between other ports in the Irish Sea. The size of their vessels enabled them to access many ports that larger vessels were excluded from because of their length or tonnage. (*Courtesy of Mannin Postcards*)

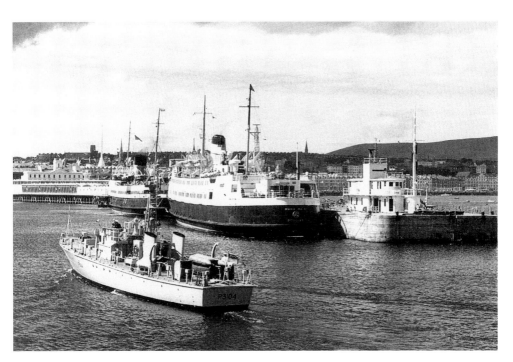

HMS *Dee* (P3104) arrives at Douglas Harbour as *Manxman* and *Manx Maid* prepare to sail for Liverpool on a summer Saturday afternoon in 1966. HMS *Dee* was built as HMS *Beckford* and was a Ford-class seaward defence boat, designed to detect and attack submarines in inshore waters. They were fitted with conventional anti-submarine armament of depth charge throwers with a single Bofors 40mm gun. HMS *Beckford* was renamed HMS *Dee* in 1965 and served as a tender to Liverpool University Royal Naval Unit.

The Isle of Man Steam Packet Company passenger vessel, the *Manxman*, sails from Douglas to Liverpool in 1969. On the 16 May 1966 the National Union of Seamen launched its first national strike since 1911 in an attempt to secure higher wages and reduce the working week from fifty-six to forty hours. The strike came to an end on 1 July that year and *Manxman* was the first vessel to arrive at Douglas from Liverpool with passengers the following day.

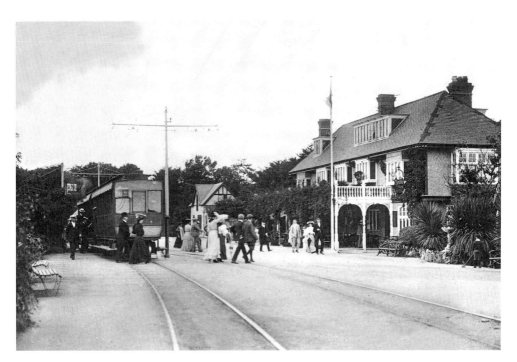

Groudle Station in 1906. The station at Groudle was famous for its flower beds and the Swiss-looking hotel. The name 'Groudle' is said to have derived from a former owner, a Mr Grow. There was a path between the hotel and a refreshment pavilion leading down to the glen and Lhen Coan, which is translated as 'the lonely valley'. The stream cuts a passage from the Onchan hills and the sides are covered with trees, mosses and ferns. The Cliff Coast Miniature Railway ran the mile from Lhen Coan to Sea Lion Rocks.

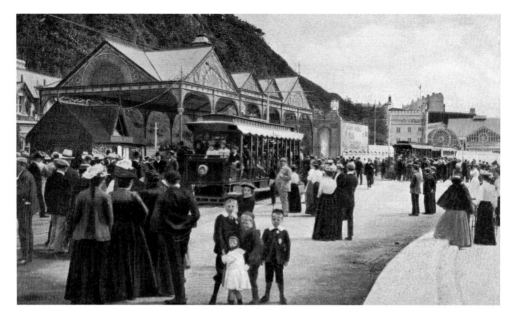

The electric tram station at Derby Castle. Work on the railway began in 1893 and a depot, workshop, inspection pits and boiler houses were built at Port-E-Vada Creek, now Derby Castle. The name 'Derby Castle' came from a residence that had occupied the site since the early 1800s. The regular service commenced to Groudle on 7 September 1893 and continued for seventeen days until it was closed for the winter. The fare was 3d and 20,000 passengers were carried during this period. The first section of the line consisted of a 2.5 mile track adjacent to the cliff road. The gauge was 3ft, which was similar to the steam railway, and the steam driven generators and switchboard gear was supplied by Mather and Platt of Manchester, while the cars and trailers were provided by G.F Milnes of Birkenhead. An extension to Laxey was authorised by Tynwald and by 1894, the Groudle track was doubled and extended.

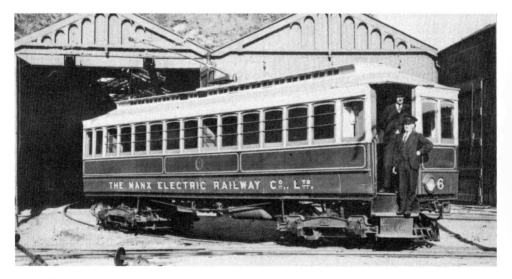

Manx Electric Railway No. 6 at Derby Castle car sheds in 1939.

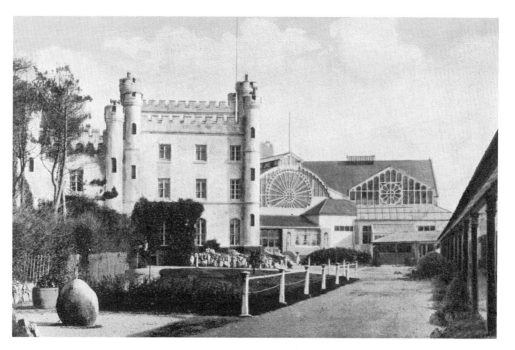

Power is provided by a 500-volt supply, the maximum Board of Trade regulations allowed. The combined Laxey and Laxey Temperance Bands celebrated the opening of the extension of the line on 28 July 1894. The line enabled power to be available for the Douglas Bay Hotel, and Onchan was the first to have new street lighting. A double 3ft 6in gauge track was adopted for an extension of the track by the Snaefell Mountain Railway in 1895. The mountain service commenced on 21 August that year and the climb from Laxey takes 30 minutes. The Snaefell Mountain Railway was bought out by the Isle of Man Tramways and Electric Power Company in 1895, with the intention of extending the line to Ramsey. The line reached just short of Ramsey in 1898 and was extended to the town the following year, completing the 17.5-mile route. The Manx Electric Railway took over in 1902, the year that King Edward VII and Queen Alexandra travelled to Ramsey in trailer No. 59. The Manx Electric and Isle of Man Steam railways are the longest narrow gauge railways of their kind in Britain.

The Manx Electric Railway.

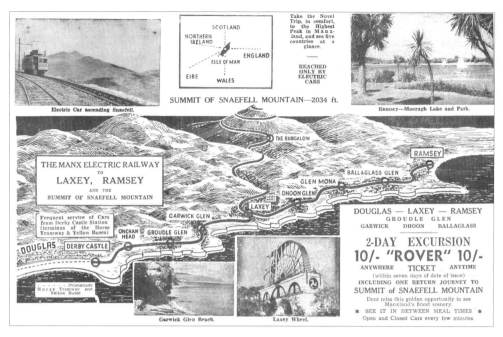

SUMMIT OF SNAEFELL MOUNTAIN—2034 ft.

Electric Car ascending Snaefell.

Ramsey—Mooragh Lake and Park.

Take the Novel Trip, in comfort, to the Highest Peak in Manxland, and see five countries at a glance.

REACHED ONLY BY ELECTRIC CARS

THE MANX ELECTRIC RAILWAY
TO
LAXEY, RAMSEY
AND THE
SUMMIT OF SNAEFELL MOUNTAIN

Frequent service of Cars from Derby Castle Station (terminus of the Horse Tramway & Yellow Buses)

DOUGLAS — DERBY CASTLE

Promenade Horse Tramway and Yellow Buses

THE BUNGALOW

RAMSEY

BALLAGLASS GLEN

GLEN MONA

DHOON GLEN

LAXEY

GARWICK GLEN

ONCHAN HEAD GROUDLE GLEN

Garwick Glen Beach.

Laxey Wheel.

DOUGLAS — LAXEY — RAMSEY
GROUDLE GLEN
GARWICK DHOON BALLAGLASS

2-DAY EXCURSION
10/- "ROVER" 10/-
ANYWHERE TICKET ANYTIME
(within seven days of date of issue)
INCLUDING ONE RETURN JOURNEY TO
SUMMIT of SNAEFELL MOUNTAIN
Dont miss this golden opportunity to see Manxland's finest scenery.
* SEE IT IN BETWEEN MEAL TIMES *
Open and Closed Cars every few minutes.

The Manx Electric Railway.

Hotel at the summit of Snaefell Mountain. The original building was of timber construction and this was replaced by a stone structure in 1902, featuring castellated turrets. However, in 1982, a fire destroyed this building and it was closed for two years. A bowser of drinking water is delivered to the restaurant each day by tram and at one time, there was a bar located in the building. It is claimed that from the summit you can see seven kingdoms at a glance. These are England, Scotland, Wales, Ireland, Mann, the kingdoms of Heaven and the sea.

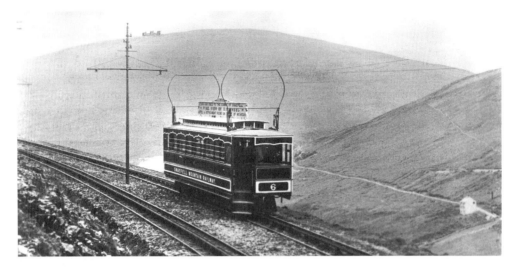

Electric car climbing Snaefell Mountain. The electric cars still in regular service consist of Nos 1 and 2, built in 1893 and now restored; Nos 5,6,7 and 9, built in 1894; No. 16, built in 1898; Nos 19,20,21 and 22, built in 1899. All of these were built by G.F Milnes & Company Limited of Birkenhead. Nos 25, 26 and 27 were built in 1904 by the Electric Railway and Tramway Carriage Works, Preston. No. 31 was also built in 1904 at Preston and the last to be introduced was the No. 32, built by the United Electric Car Company Limited at Preston.

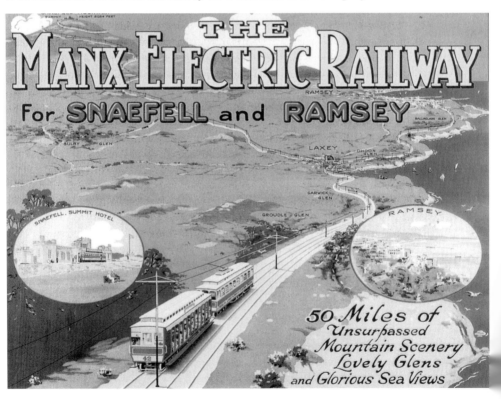

The Manx Electric Railway.

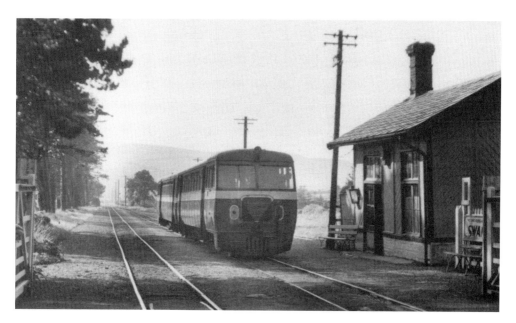

Railcars No. 19 and No. 20 for Douglas at Crosby, on 2 September 1964.

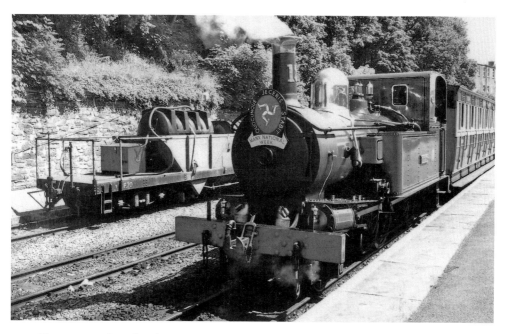

The steam railway has been compared to the three legs of Mann as it comprised of three main routes. The southward route from Douglas to Port Soderick, Santon, Ballasalla, Castletown, Port St Mary and Port Erin. The westward route from Douglas to St John's and Peel and the northward route from St John's to Kirk Michael, Ballaugh, Sulby and Ramsey. There was also a short branch from St John's to the village of Foxdale. Today, the train takes you from Douglas Station to Port Erin, in the far south of the Island and is all that remains of the island's network of steam railways.

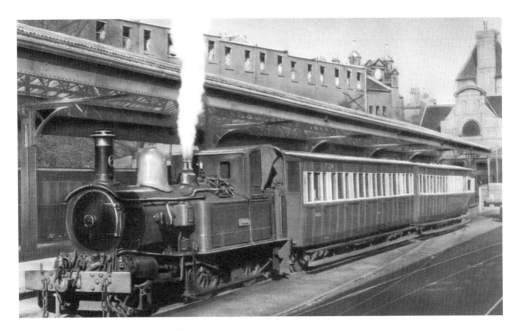

Steam locomotives leaving Douglas Station.

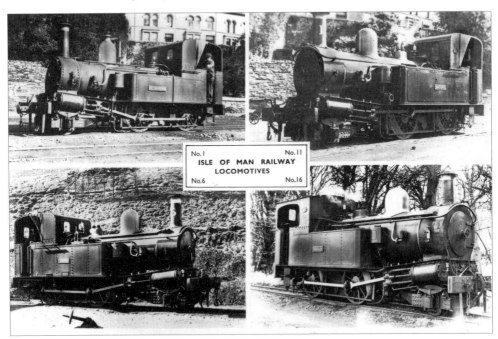

Isle of Man Railway locomotives.

Convenient Services and Cheap Facilities

From Principal

GREAT WESTERN RAILWAY STATIONS

to the

ISLE OF MAN

Via BIRKENHEAD

(Connecting with the Douglas Boat at Liverpool Landing Stage)

SPECIAL DAYLIGHT SERVICES

During the Summer.

Breakfast in London ! :: :: Dinner in **Douglas** !

TIME OCCUPIED
TO
DOUGLAS
FROM

	Hrs.	Mins.		Third Class Monthly Return Fare	
LONDON (PADDINGTON)	9	50	...	47	9
BIRMINGHAM (Snow Hill)	7	45	...	29	5
BRISTOL	10	35	...	43	7
CARDIFF (General)	10	0	...	41	6
CHESTER	5	27	...	16	3
EXETER (St. David's)	16	15	...	56	8
GLOUCESTER	11	45	...	37	0
HEREFORD	8	33	...	32	3
NEWPORT	9	39	...	39	5
PLYMOUTH (North Road)	18	0	...	65	11
SHREWSBURY	6	36	...	23	4
SWANSEA (High Street)	11	15	...	42	6
WOLVERHAMPTON (Low Level)	7	20	...	27	4
WORCESTER (Shrub Hill)	9	18	...	32	0

All details of Train Services, etc., obtainable at G.W.R. Stations and Agencies.

Isle of Man Railway and Manx Electric Railway timetable and fares, 1923.

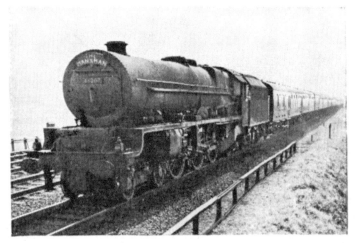

The "Manxman", which leaves Euston for Liverpool every weekday morning throughout the holiday season, is only one of the many trains serving ports for the Isle of Man.

BE SURE TO COME
BY RAIL AND SEA....

Let the journey be part of your holiday, while you relax in comfort and contemplate the pleasures ahead. To help you, British Railways have many facilities to offer :—

RETURN TICKETS AVAILABLE FOR THREE MONTHS, permitting break of journey at any station on the direct route.

LUGGAGE IN ADVANCE conveyed to and from Douglas at a moderate fee.

MID-WEEK HOLIDAY RETURN TICKETS (2nd Class only) to Douglas, at reduced fares, are issued from most stations from May to October, available outward by sailings on Tuesdays, Wednesdays and Thursdays, and return on Tuesdays, Wednesdays or Thursdays the following week or week after that.

ALL-IN HOLIDAYS IN THE ISLE OF MAN—travel, hotel accommodation and sightseeing trips for one or two weeks— available during the holiday season, departing on Tuesdays and Saturdays from London, Leicester, Nottingham and selected stations in Yorkshire, Northumberland and Durham, and from Birmingham on Tuesdays only.
There are reduced rates for holidays starting on Tuesdays.

Further particulars will be gladly supplied on application to Stations or Agencies.

British Railways advertisement, 1960.

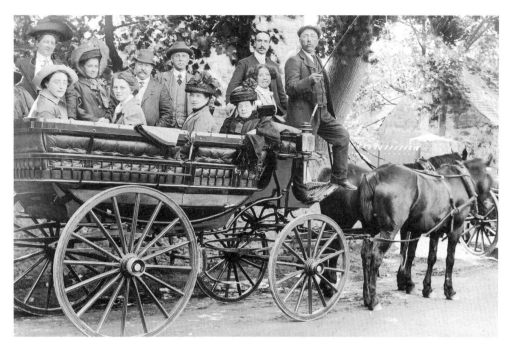

Horse-drawn transport in Douglas. The photograph is entitled 'Will and Ethel in 1910'.

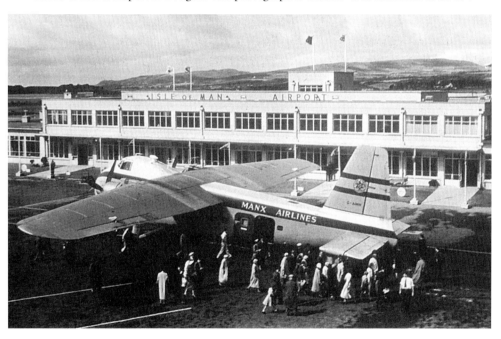

Ronaldsway Airport Terminal. The airport is situated on the south-east coast of the Island, near Castletown and is 9 miles from Douglas. Derbyhaven, which is close to the present airport, was once the main port and the Vikings used the beach to supply their stronghold at Castle Rushen. The path they used was Ronald's Way and the flat area was later a natural landing ground.

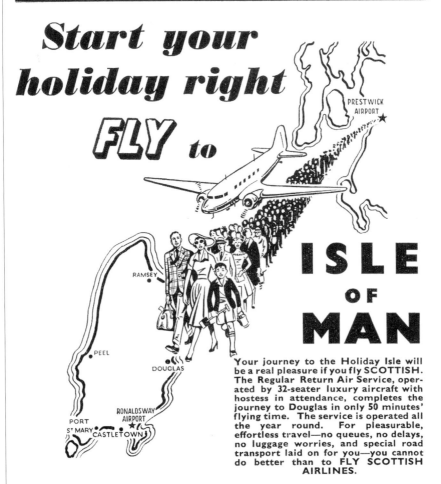

Start your holiday right FLY to

ISLE OF MAN

Your journey to the Holiday Isle will be a real pleasure if you fly SCOTTISH. The Regular Return Air Service, operated by 32-seater luxury aircraft with hostess in attendance, completes the journey to Douglas in only 50 minutes' flying time. The service is operated all the year round. For pleasurable, effortless travel—no queues, no delays, no luggage worries, and special road transport laid on for you—you cannot do better than to FLY SCOTTISH AIRLINES.

Return Air Fare £6·12·0
(This Air Fare is correct at time of going to press but is subject to alteration without notice)

For full details and reservations apply to :

Scottish Airlines
PRESTWICK AIRPORT AYRSHIRE
Telephone : Prestwick 77281

Scottish Airlines advertisement.

fly BEA

to the

Isle of Man

from

BELFAST · GLASGOW

LIVERPOOL · LONDON

MANCHESTER

Details and reservations
from Principal Travel Agents
or local BEA offices.

BRITISH

EUROPEAN AIRWAYS

'Fly BEA' to the Isle of Man advertisement.

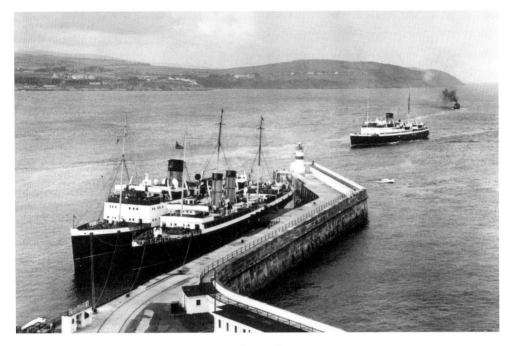

Steamers berthed at the Battery Pier, in Douglas Harbour.

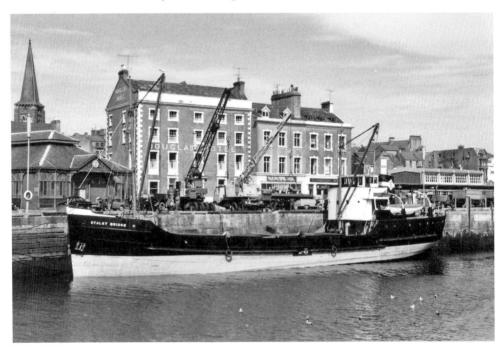

Staley Bridge unloading cargo in the inner harbour at Douglas.

9

MANX TRADITIONS, CUSTOMS AND SCENERY

Fishing in the Silverburn River. The river runs south through Ballasalla to Castletown and the two branches meet just above the Monk's Bridge, near Rushen Abbey. It is a very popular location for anglers.

Ballaglass Glen. The stream flows down in a series of cascades that has worn the rocks into many shapes. It is crossed by rustic bridges and trees are often left in place where they have fallen across the river.

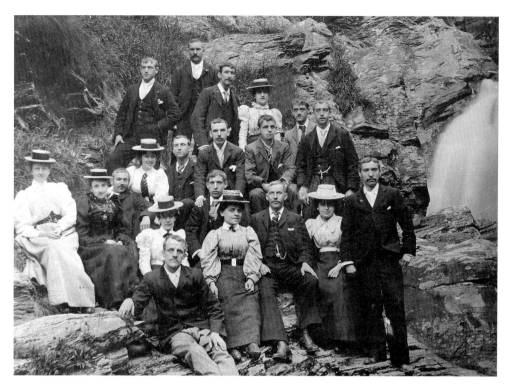

A group photograph by a waterfall that was taken by John W. Walton of No. 53 Athol Street, Douglas who also had branches at Glen Helen, Rushen Abbey, Groudle Glen, Laxey Glen Gardens, Glen Maye and Garwick. The Island offers a variety of spectacular scenery due to the diversity of its geological strata. It ranges from smooth treeless uplands to wooden glens, lush pastures and wild rock bound coasts. Hidden away among the high headlands and rocky cliffs are little coves and sheltered bays with miles of sandy beaches.

Manx cat and kittens.

A group in traditional costume at Cregneish in the 1960s. 'Cregneish' is the most southern village on the island, and at the beginning of the twentieth century the inhabitants were employed mainly in farming and fishing. The stone circles in the area point to the village being continuously inhabited from Neolithic days. Above the village is a circle that consists of six tritaphs and north-north-east of this is a village of stone huts.

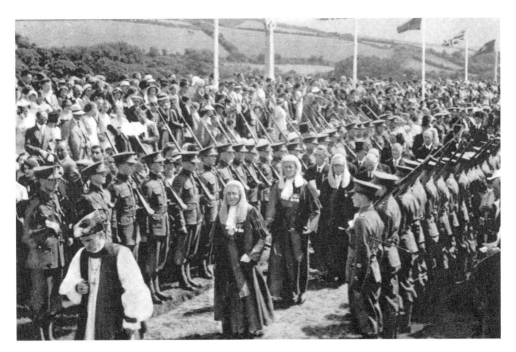

Tynwald ceremony at St John's. Tynwald is over 1,000 years old and has the longest continuous history of any legislature in the world. The keys were chosen from the chief landowners and the assembly where they met was the 'Tingvollr', from which is derived the name Tynwald. The Tynwald Court is made up of the Lieutenant Governor, who represents the Queen as Lord of Mann, the Legislative Council and the House of Keys. The Legislative Council is the upper house and comprises of eight members elected by the Keys, the Lord Bishop and the Attorney General, who does not have a vote. The members elect one of their number as President of the Legislative Council. The lower house is the twenty-four Members of the House of Keys elected for a term of five years. The Speaker of the House of Keys is elected by members. At the annual Tynwald Fair Day, the Tynwald Court meets in an open-air assembly to announce new laws. In 1979, Her Majesty the Queen attended and presided over the Millennium Tynwald at Tynwald Hill.

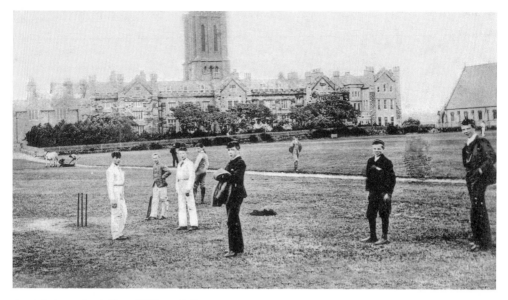

A cricket match at King William College.

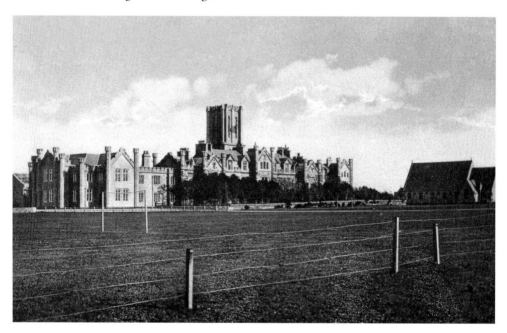

King William College, Castletown.

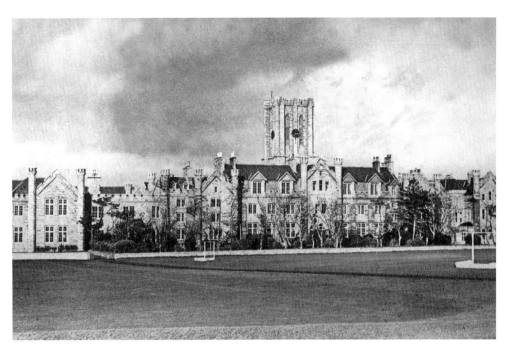

King William College, Castletown. In 1663 Bishop Barrow took possession of two farms. Hangohill and Ballagilley in Maew to fund sending candidates to Dublin University to study theology. The Bishop Barrow's Trust increased and Earl William proposed that the trust be used to found a Manx University. However, it was later decided to found a public school. The trust continued to increase and in 1830 the Governor, Colonel Cornelius Smelt proposed that it be used in a better way. The trust totalled £5,000 which was an insufficient amount to build a school and the Bishop mortgaged the land and publicised the need for an educational establishment on the Island. When King William IV was approached he apologised for being unable to contribute to the fund but informed the trust that he would give his name to the new college.

The Tynwald ceremony.

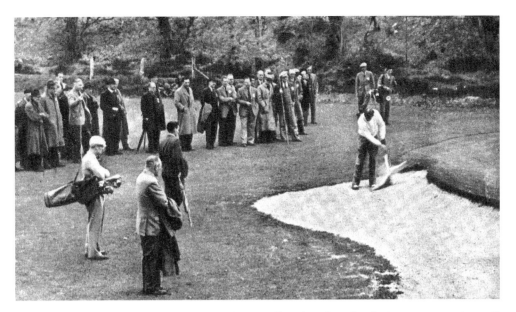

Manx Open Golf Championship at Pulrose Golf Links. The Isle of Man possesses nine golf courses and eight of these are full sized. They are easily accessible from the towns and the nature of the ground presents a series of problems for the golfer.

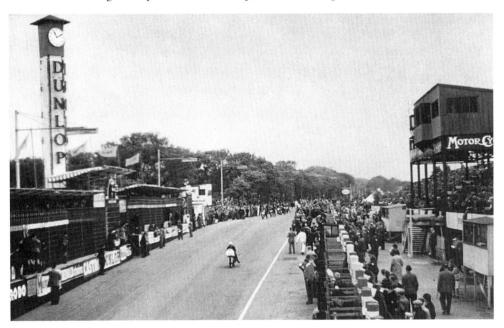

Start of the International Senior TT Race in 1958. The start and finish of the races are at Douglas, where a broad highway incorporates the racing pits, spectators' stands and the scorecards and clocks. The circuit covers 37.5 miles over lonely moors, narrow village streets, steep hills, hairpin bends and hump-backed bridges. Stands are erected at all the main vantage points and these are linked by observers and commentators who inform spectators of the progress of the riders in the race.

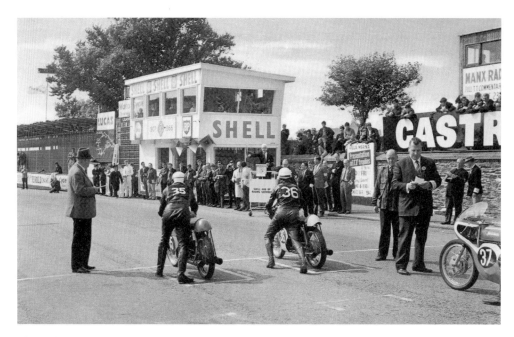

The world famous Tourist Trophy and Manx Grand Prix races take place every year and attract motorcyclists and tourists from around the world. The road circuit is closed to all other traffic during the races.

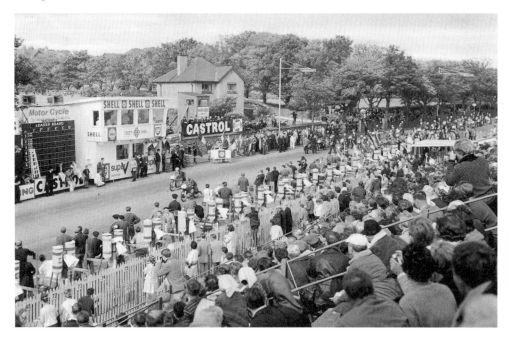

Many of the enthusiast who come to the island also bring their bikes with them and are able to enjoy riding around the course prior to the start of the races. The Tourist Trophy and Grand Prix races bring revenue to the island's economy and to the people who provide services to the thousands of visitors who arrive by sea and air to witness the events.

Rushen Abbey
Historic Gardens

*with Leisure Park, Archaeological Burial
Ground, Museum, Craft Shop and Art Stall,
Peacocks and Loghtan Sheep,
Garden Centre, Discount Store,
Souvenir Shop and
Strawberry Parlour.*

Abbot's Inn
Licensed Bar — Cafe
Afternoon Entertainment

AVIARY, ANIMAL ENCLOSURE,
MINI MOTOR BIKES and JEEPS —
ROUNDABOUT and FUN CASTLE.

**Daily Treasure Hunt prize with major prize
at end of Season.**

Sunday Markets: 5th May to 15th Sept.
Tuesday Markets: 25th June to 3rd Sept.

**ALL AT RUSHEN ABBEY,
BALLASALLA
Telephone 823015**

Rushen Abbey and historical gardens.

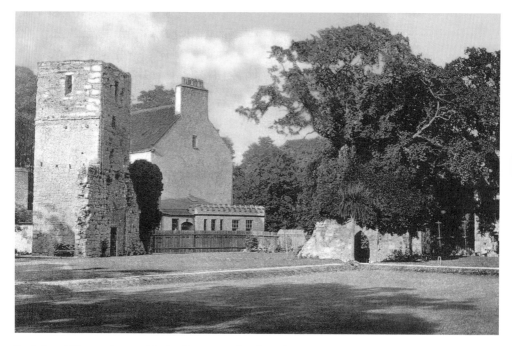

Rushden Abbey ruins in 1911. The grounds of Rushen Abbey contain the ruins of the island's only monastic establishment. The abbey is believed to have been erected on the site of an early Christian church. The land was granted in 1098 but the monastery was not built until thirty years later. King Olaf I had adopted Christianity from the Celts he had conquered and, following his time at the court of King Henry I, he brought the monastic orders to the Island. It was a Cistercian foundation, controlled by the Abbot of Furness. The sign in the grounds bears the following:

> Founded 1098. Built 1134. Robbed by Sir Richard de Manderville on Ascension Day, 1316. Confiscated by Henry VIII of England, April 11th 1537. Sold by James I to the Earl of Derby for £101 15s 11d, yearly, May 2nd 1611. Given by Charles I to his most beloved Lady, Queen Henrietta Maria, 1626. In possession of More, Esq., 1773. Purchased by John, 4th Duke of Athol 1830. Purchased by Thomas Cubbon Esq., 1893.

Excavations of the building in 1914 laid bare the foundations of the church, cloisters, chapter house, fratery, kitchen and workrooms. The graves of four abbots were discovered and a coffin lid was that of King Olave II of Man, who was buried on 21 May 1237.

The monks recorded the history of the abbey in the Chronicon Manniae and the lay brothers, who took vows of poverty, chastity and obedience performed the manual work. The abbey also exported corn, hides, salt fish, wool, and lead through the port of Ronaldsway. These were exchanged for foods, cloth, silks, timber and iron. Rushden Abbey was the last to survive following the Dissolution by Henry VIII and the Earl of Derby bought the silver plate in 1541 when the abbey's lands were sold. The abbey was converted into a school for young ladies and the Abbey Hotel in 1846. The grounds were used as a fruit garden producing strawberries and Rushen Abbey jam.

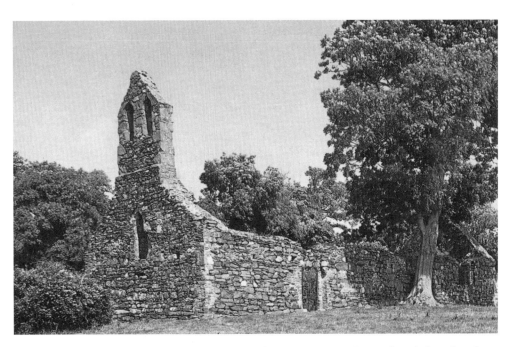

The roofless remains of St Trinian's Church. St Trinian or 'Ninian', is believed to have been a fifth-century bishop of the Picts, and the church was a dependency of the Priory of Whithorne in Galloway. The building is 70ft by 25ft and the walls are pierced at a height of 6ft by small square holes. (Copyright Bamforth & Co. Ltd)

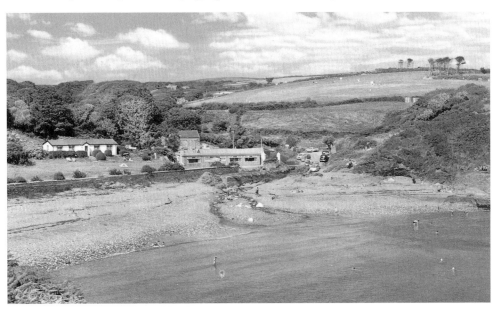

Port Grenaugh is approximately 1.5 miles from Santon. It is a bay at the end of Glen Grenaugh and is at the mouth of a stream that originates in the Newtown area of the parish by Ballakissack farm. It is close to Cronk ny Merriu, one of the promontory forts which date back 2,000 years.

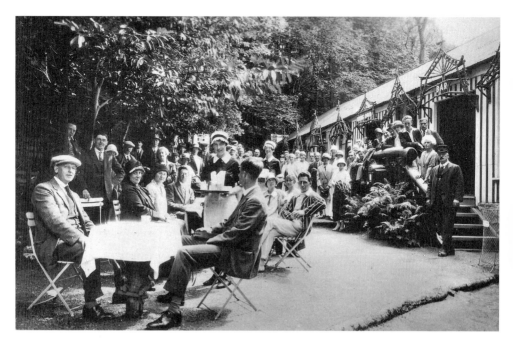

Tholt-y-Will, Sulby Glen Hotel and Tearooms. The high ground above the hotel provides magnificent views of the mountains and Tholt-y-Will Fall. The hill standing at the entrance to the Glen is Cronk Sumark or Primrose Hill, a prehistoric fort. It is very similar to Arthur's Seat at Edinburgh and it is claimed that Sulby Glen displays the boldest and most rugged scenery of all the Manx glens. The total length of the Glen from the village to the sources of the river on the slopes of Pen-y-Pot, Snaefell, and Sartfell is 6 miles.

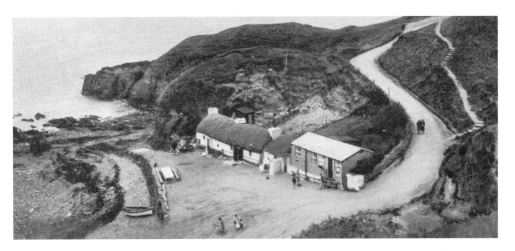

Niarbyl Point provides a good view of the bay and the cliffs of Bradda Head, with the western edge of the Calf visible in the background. It is claimed that Niarbyl has one of the finest views for coastal scenery in the British Isles. Niarbyl Bay and Fleshwick Bay merge into each other, and are not strongly marked indentations. There is a long wall of lofty cliffs, rising north of Fleshwick to a height of over 1,000 feet.

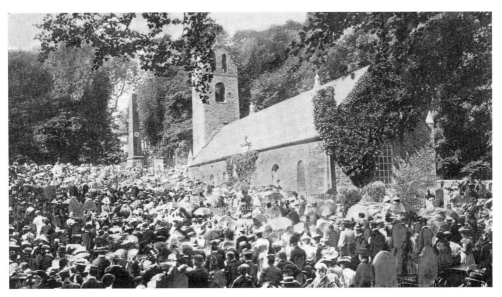

Sunday outdoor service at Kirk Braddon Church in 1905. Old Kirk Braddon dates back to 1773 and incorporates earlier churches on the site. It was founded in the fifth or sixth century and incorporates several sculptured Scandinavian runic crosses. One of the crosses was used for several years as a doorstop and most are covered with intricate knot work and with grotesque figures of animals and fish. They date back to the eleventh, twelfth and thirteenth century. The largest cross bears the inscription in ancient Scandinavian, 'Thorleif Hnakki raised this cross to the memory of Fiace, his son, brother's son to Hafr.' It is recorded that a church stood on this site as far back as 1291, for in that year Mark, bishop of the island from 1275–98, held a synod here and enacted thirty-four canons. Braddon is derived from St Brandon, or Brandinus.

Glen Maye in 1913. The name in Manx is, 'The vale of luxuriance' and it is part of Glen Rushen, a deep valley running inland to the north-west side of South Barrule. The village is on the Coast Road, 5 miles south of Peel, in a wooded valley. It is popular for artists and trout-fishers. There is a bus service from Peel but many take the path that was one of the favourite walks of T.E. Brown.

Craigneash Village is best approached by taking the hill road commencing at the south-east corner of Port Erin bay, taking the left branch at the fork, passing half a mile to the right of the Stone Circle. From Craigneish the walker can proceed to the narrower end of the Sound overlooking Kitterland, or take the tracks leading to Spanish Head and the Chasms.

Ballalona Fairy Bridge is in the parish of Malew on the road from Douglas to Castletown, just below Ballalona Bridge in Ballalona Glen. It is claimed that it is unlucky not to greet the fairies (or 'ferrish') when crossing the fairy bridge. The tradition is always taken seriously by Manx people and visitors, and many motorcyclists visit the bridge before setting out for practice, as accidents and crashes are blamed on the fairies' displeasure.

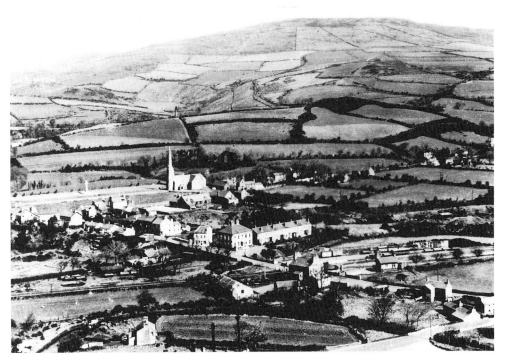

St John's Village is a small village on the Douglas to Peel Road and was the junction of the two main railway lines as well as the line to Foxdale. The village is the scene of the annual Tynwald Ceremony that is held every year on 5 July. The Anglican church of St John's contains reserved seats for members of the two chambers of the Manx Parliament and the church hall has an exhibition detailing the history of Tynwald. On the north side of the village is the Tynwald National Park. In recent years, the site of the old Tynwald Woollen Mills has been converted to a craft and shopping centre.

If you enjoyed this book, you may also be interested in …

Directories of British Tramways: Northern England, Scotland and the Isle of Man, Volume 3
KEITH TURNER

As trams and other light rapid transit systems make a comeback in many British cities, this packed volume, the third in a trilogy, looks at all the tramways that have operated in the towns and cities of northern England, Scotland and the Isle of Man, with lines as far apart as Aberdeen and Chester. From the 1870s to the 1950s trams were a common sight in many British towns and one sorely missed by many enthusiasts. This illustrated book is a practical and useful tool revealing the tramway lines and networks of the British Isles, with archive photographs and informative text.

978 0 7524 4239 6

The Isle of Man: A Pictorial History
D. ROBERT ELLERAY

The Isle of Man is not just an island. It is a small, but successfully independent country with institutions and traditions that span more than a thousand years. Tynwald was an effective parliament long before Westminster, while the Manx Church predates the dioceses of both Canterbury and York. Its position in the Irish Sea has allowed the Manx identity to flourish and has ensured a succession of strong influences from seaborne settlers and rulers … Irish, Norse, Scots, and English. Though all have left their mark, the island remains unmistakably Manx.

978 0 85033 677 1

Visit our website and discover thousands of other History Press books.

www.thehistorypress.co.uk